This authoritative work is devoted exclusively
to the subject of equidensitometry
which was conceived and developed by Lau and Krug.
Equidensities are lines or curves of equal density
on a photographic plate: they represent
the isophotes and the isolux and isostilbs respectively
and other photometric properties of an object,
and are analogous to the isohypses (contour lines)
on the map of a landscape. Equidensitometry
is an automatic method of two-dimensional photometry
and makes new methods of evaluation available
for the analysis of photomicrograms,
contour images, interferograms, etc.
and in every case enhances considerably
the accuracy of the measurements.
This book, which is the first to give a complete coverage
of this new and much discussed method of measurement,
will represent a valuable contribution
to the works of reference
of scientists and technicians employed in
many research and industrial laboratories.

EQUIDENSITOMETRY

EQUIDENSITOMETRY

*Methods of two-dimensional photometry,
principles and fields of application*

Prof. Dr. Ernst Lau and Dr. Wolfgang Krug

Institut für Optik und Spektroskopie
der Deutschen Akademie der Wissenschaften zu Berlin
Berlin-Adlershof

THE FOCAL PRESS

LONDON and NEW YORK

Translated by Grace E. Lockie, B.Sc.

from

"Die Äquidensitometrie"

© 1957 Akademie-Verlag GmbH
Berlin

Printed and bound in Germany (East)
at VEB Leipziger Druckhaus, Leipzig

CONTENTS

FROM THE PREFACE TO THE GERMAN EDITION

Many years have now passed since the authors attempted to increase the accuracy of measurements made on a few interferograms, by means of the photographic production of curves of equal density (equidensities). It soon became evident that the questions broached were of a much more universal nature, and that these methods made possible the two-dimensional photometry of images and thus constituted an important contribution to some of the foundations of scientific photography.

Two points of view were the governing factors in the writing of the present book. Firstly, the wish which was frequently expressed to the authors for an introduction to the practical use of equidensitometry had to be taken into consideration, and secondly, it became apparent that single lectures or articles were insufficient to explain or even to clarify the new types of and often complicated problems in scientific photography and photometry posed by equidensitometry. Sometime, therefore, a compilation of these questions had to be made.

The range of problems arising in equidensitometry is still too recent for the present representation to be regarded as final and correct in every respect. Scientific knowledge will become more profound and thus many things will change or appear in a new light.

The use of equidensitometry can probably be recommended for a very great variety of tasks. The fields of application which are dealt with here have only been touched on and we do not doubt that the subject will soon expand in various directions.

If this book facilitates the use of equidensitometry and arouses interest in theoretical and experimental studies, it will have fulfilled its purpose.

Berlin-Adlershof, June, 1956 The authors

PREFACE TO THE ENGLISH EDITION

Since the publication of "Equidensitometry" in 1957, the method of equidensities has been introduced into many branches of science and technology. This is evident from the voluminous literature index given at the end of the book. In bringing out an English edition of the book it would not be correct simply to present a translation of the German book, because much that is new has arisen in the meantime, and a great deal has been added to the subject. It will therefore doubtless be welcome if we take into consideration as much as possible the work which has been done in this field during the last 10 years. Since it is not intended to increase the size of this edition appreciably, a considerable amount of the material in the original version has had to be removed or abridged. We hope that this has been done without detracting appreciably from the value of the book as a whole.

For assistance in preparing the new edition we should like to express our thanks in particular to *E. Gehrmann* and *J. Schusta* (electronic equidensograph), *I.L. Kofsky* (Isodensitracer), *A. Rakow* (radiation physics), *G. Hess* and Mrs. *L. Tesch* (the practical production of equidensities) as well as to *H. Bethge, J. Heydenreich, F. Hodam, W. Högner, J. Märker, W. Mieler, N. Richter* and *H. Schmidt* for providing material for the illustrations and not last to Mrs. *A. Cosslett* for many useful discussions.

Berlin-Adlershof, March, 1967 The authors

I. INTRODUCTION

The word *equidensities* means *lines* or *curves of equal density*. *Equidensitometry* therefore signifies *methods of measurement* based on *equidensities*. By *equidensito-metering* is understood a procedure for obtaining specific curves of equal density from a photogram.

Any method of producing curves of equal density, say by point-by-point photo-metering, is known to be very tedious. In the following, an automatic, continous *two-dimensional* method of photometry will be described, that is, one in which the curves are obtained in one operation from the photogram by means of specific photographic or electronic processes. From the equidensities, the isophotes or isostilbs (or isolux) in the photographic object can be developed, such values having hitherto to be determined point by point by photometric means, possibly by the use of the *Equidensito-mètre* described by *M. M. Jobin* and *Yvon* (1934), or by the photographic-photometric method indicated by *R. Sewig* (1935), or again by other methods of density measurement and sensitometry. (Cf., for example, *Zorll*, 1952). These older methods will not be dealt with here.

It was not until 1952 through the publication of an article and two patents by the authors (*Krug* and *Lau*, 1952) that photographic and electronic equidensitometry was introduced into science and technology. The problems which were broached in these publications were worked through systematically in the *Institut für Optik und Spektroskopie* (Berlin-Adlershof), and in a few years a whole series of methods of two-dimensional photometry was developed (*Krug* 1959).

Equidensitometry is applicable in every case which presents a continuous run of densities of varying degrees of image spread: image analysis, or the evaluation of a photogram of this kind by practical measurements is usually difficult. A family of equidensities enables the photometry of the image to be carried out in two dimensions, and the sharp curves which are obtained render the evaluation more accurate or at all possible. This is because the eye is quite incapable of seeing equidensities correctly in flowing contours, or because errors in the actual intensity distribution are brought about by contrast vision, (*Gehrcke* and *Lau* 1921, *Lau* 1938). This is illustrated by the following example. Figure 1 shows a reproduction of the surface of a cone on which illumination which is incident obliquely to the axis has given rise to a certain distribution in the brightness. Although the individual radii on the circular surface which is seen must be of equal brightness because they lie at the same angle to the direction of the incident light, this is by no means how it appears to the eye. Subjectively the sides of the cone appear to rise gently upwards, and the apex in the centre stands out like the pike of a shield.

Whatever physiological mental arguments may be adduced to account for this phenomenon, the outlines of the shadows appear curved to the eye. Objectively, however, at all events in the original object, each equidensity runs strictly radially, and this can easily be proved by laying a slit on top of the copy (see also Fig. 49, p. 61).

In measuring photograms (photomicrographs, shadowgraphs, interference photographs, diffraction images), the eye has usually to make use of blurred contours for the points of measurement, and is subjected to random fluctuations in the contrast relations when interpreting the image. Thus, as demonstrated in Fig. 1, errors of

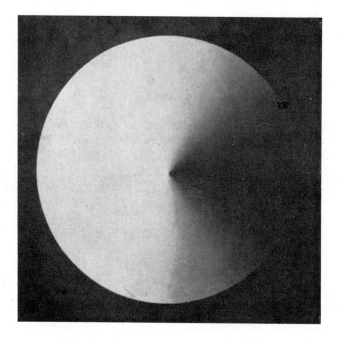

Fig. 1. Contrast vision and intensity distribution.

varying magnitude are liable to occur in making the measurements. It is obvious that the limitation in the accuracy of the photographic measurements is often attributable solely to defects in contrast vision. Lines of equal density can remove these defects in many cases: the accuracy of the measurements increases considerably if one is in a position to obtain equidensities of adequate sharpness.

II. THE NEED FOR EQUIDENSITOMETRY

The development of the equidensitometry method was prompted by the problems which arise when measurements are made on interference fringes. In evaluating interferograms, it is often essential to follow the course of the fringes in detail and to determine fringe displacements as accurately as possible in fractions of the fringe spacing. The higher the contrast of the photographic image, the more accurate are the results of these measurements. The intensity distribution of a two-beam interference pattern is sinusoidal along a line perpendicular to the fringes (cf. 5.1), and it is evidently not feasible to use the relatively broad intensity maxima as a basis for measurements. Similarly, the edges of the fringes are more or less blurred out, so that these too allow

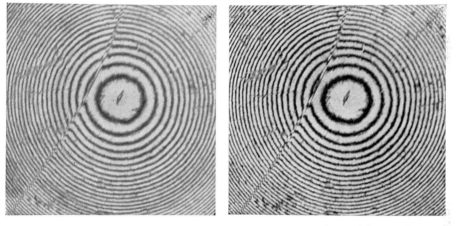

Fig. 2. Interference photograph (soft).　　　Fig. 3. Interference photograph (hard).

Surface of a sphere with a scratch about 0·25 μm deep.

only limited accuracy in any measurements. To the observer, however, the brightness distribution (or density distribution) appears considerably steeper than it actually is, so that fringe displacements of 10% of the fringe spacing can usually be measured without difficulty (see Fig. 2). Suppose Hg green light, of wavelength $\lambda = 5460$ Å, is used, then this 10% of the spacing represents about $\lambda/20 = 0\cdot034$ μm in the profile height, if the interference fringes are considered as contour lines of vertical interval $\lambda/2$.[†]

[†] In this connection the reader is referred to the testing of reflecting surfaces by means of interference fringes of equal thickness, for which purpose interference microscopes are employed. See, for example, the work of *K. Räntsch* (1943), *J. Dyson* (1950, 1955), *B. Edenholm* and *E. Ingelstam* (1954), *B. Edenholm, C. E. Johansson* and *E. Ingelstam* (1959), and also the monograph by *Krug, Rienitz* and *Schulz* (1964).

The edges of the fringes can be made considerably sharper if the pattern is either photographed or copied on a hard or extra hard photographic emulsion (*Räntsch* 1952). The details of the fringe displacements are not lost in this process, as long as the contrast is not made excessive, and the accuracy can be increased to at least $\lambda/60 = 0.01$ μm (see Fig. 3). This accuracy, while sufficient for many purposes, by no means approaches that obtained with multiple beam interference, for example in the measurement of crystal steps and the thickness of thin films (*Tolansky* 1948). The extremely steep intensity distribution of some of these multiple-beam interferograms readily permits measurement of displacements of 1/300 of the fringe spacing, corresponding to $\lambda/600 = 0.001$ μm or 10 Å in the profile height (see Fig. 4). However, certain reserva-

Fig. 4. Multiple-beam interference fringes on mica, step about 65 nm (*Tolansky*).

tions must be made and this matter has been discussed repeatedly in the literature (*Ingelstam* 1953, *Krug* 1955, 1956), and a further brief discussion will be given in section 6.4.2.

A two-beam interferogram may similarly be expected to contain all the details of the surface relief, which can therefore be evaluated from an interferogram of this type. Evidence for this is found in the fact that, by photometry across the fringes of a two-beam interference pattern, fringe displacements can be pin-pointed with an accuracy of 1/1000 of the spacing. (*Zorll* 1952). This photometric method is especially suited to situations such as, for example, single steps on a surface, where the approximate direction in which to photometer is known. In the case of complicated structures photometry is in general not worth while because of the length of time involved. A number of sections across the interferogram is obtained, but the photographic emulsion would have to be photometered point by point, or scanned by a recording photometer, to evaluate a picture exhaustively. Even so it is not at all certain that the curve traced out by the photometer would show up the required features clearly. In most cases, the individual pieces of photometric data tend to be obscure and difficult to use. If a density distribution is continuous and more

or less blurred, it is preferable to be able to see all points of a given density joined together, i.e. to obtain lines of equal density. Because of their small width, well-defined lines of equal density will show up the details of, for example, interference fringes, and allow them to be evaluated with the same accuracy as can be achieved by the photometry of photographs. Each equidensity will therefore contain information about the fine detail of the interference picture. Of course equidensities obtained for two different density levels need not show the same details, on account of their differing positions; this is similar to the fact that the details of the original interference fringes depend on how the fringes happen to have been positioned on the surface. This is, however, quite irrelevant as far as observation of the average surface roughness is concerned, and in the same way all equidensities are fundamentally equivalent when used to study particular features of the fine structure of fringes, provided that the equidensities pass through the region of the plate where the detail is best resolved (*Lau* and *Johannesson* 1934, *Lau* 1952).

It is well known that these problems of increasing the accuracy of measurements, as described above, arise not only in the case of interference patterns but are of a much more general nature. This suggested carrying out a general investigation of picture analysis from the point of view of equidensitometry. The above considerations can be applied equally well to the analysis of photographs of any type, including those obtained by photomicrography and electron microscopy. Such photographs, for example pictures of biological specimens, often show a density distribution that is confusing and obscure. This density distribution is the sole basis for the interpretation of the contents of a photograph, and in most cases this interpretation has to be made by mere visual observation. Obviously it would be much easier if a photograph of this sort were used to obtain a number of new pictures, each one mapping out a particular density level in the original. In many cases, interpretation of the contents of a photograph will only be possible with the help of a series of such *equidensity images*, or at least it will be made very much easier. Furthermore, it does seem advantageous in some applications to superimpose the various equidensity images, thus obtaining an *equidensity contour* map of the density distribution.

III. THEORETICAL PRINCIPLES

3.1 *The dioptrical-photographic method*

Let us consider a section through an exposed and developed photographic layer of specific density distribution: then we can record the density D as a function of the position x on the plate.

This is demonstrated in Fig. 5. The points of equal density are those where the straight line $D =$ const. intersects the contour curve. In a two-dimensional image the points of equal density usually run together to form lines which we call equidensities. Thus it is our task to produce these equidensities photographically, i.e. to obtain in addition to the original image, a second one in which certain lines, $D =$ const., appear say as blackened lines on an unblackened background.

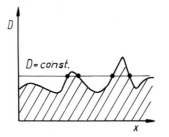

Fig. 5. The density curve on a section through a photographic layer.

This can be achieved for example by means of a positive-negative combination, which will be discussed in detail in the following sections. This method enables places in the plate with densities covering a given density range to be brought into prominence against their background which may be higher or lower in density than the places themselves. The latter appear darker than their surroundings on another photographic plate which is obtained by a suitable method.

The curves which have thus been made to stand out against their background can be called "equidensities of the 1st order". As already explained, they undoubtedly cover a still larger density range in the given plate.

This method can be used on a second plate, to obtain a third plate in which a definite, already considerably narrower density range at the sides of the equidensities is accentuated. The "equidensities of the 2nd order" are obtained in this way. If this operation is repeated about once or twice, the equidensities are finally obtained in the form of sharp lines (see section 3.1.4).

3.1.1 THE TWO-LAYER METHOD. The foregoing general considerations will now be illustrated by means of a special example.

Figure 6 shows a section of a microinterferogram of a very good spherical surface at a linear magnification of about 700 times (see section 6.4.1). Although the inter-

14

ference fringes undoubtedly show a certain amount of distortion, they do not exhibit any deflections which reach $\lambda/20$ ($= 1/10$ of the distance between the fringes) so that at all events the "hill surface" can be said to be lower than 27 nm ($\lambda = 535$ nm). Figure 7 shows the desired equidensities which do in fact clearly reveal surface details which are concealed owing to the width of the intensity curve of the double-beam interference fringes. These first stage equidensities were obtained by producing a positive of Fig. 6 and placing it in exact coincidence with the negative. The use of this method is known in photography for producing certain effects in photomontage (*Thiery* 1949). These include posterizing, which is a kind of tone separation process which was first described by *W. Romer* (1932) and for which there is a large number of possible applications (see, e.g. *G. Heymer*, 1939, *M. Schiel*, 1951, *H. Greif*, 1959

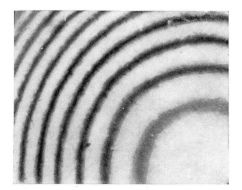

Fig. 6. Spherical surface under an interference microscope.

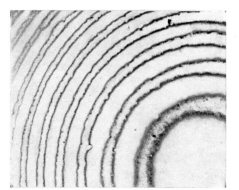

Fig. 7. Equidensities of Fig. 6.

1961, 1962), and which also represents a supplement to equidensitometry (*Greif*, 1961). Methods of this type are also used in forensic photography (*Urban*, 1911) for the detection of forgeries and so on, and also for rendering certain outlines visible in papyrus research. In the majority of cases negatives and positives are contrasted in a special manner and are not brought into exact coincidence but are shifted slightly in relation to each other. Such negative-positive combinations give the erroneous impression that it is impossible to see any kind of image when the two parts are in exact coincidence, because the transparent places in the negative are covered by the blackened places in the positive (*Croy*, 1950). This is however only strictly possible in one particular case ($\gamma = 1$) which will be considered later (section 3.1.3). If the plate used for the second component is not too soft ($\gamma > 1$), then when the places of about equal density in the negative and positive are in exact register, an equidensity is formed, as will be shown later by means of characteristic curves. In our case (Fig. 6), on observing this combination by transmitted light, each interference fringe is seen to be split up into two equidensities which may be regarded as more or less enveloping the original fringes, and likewise as contour lines. The average roughness of the surface can easily be

15

derived from this Fig. 7, and amounts to about 10 nm: the smallest, just measurable, irregularities are of the order of 60 Å or $\lambda/100$, which appears to increase the accuracy 5 times as compared with Fig. 6.

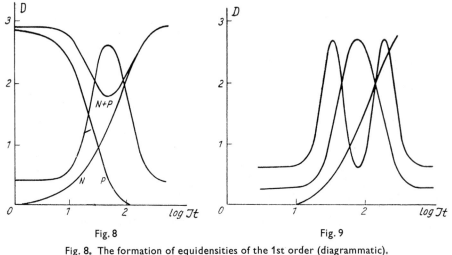

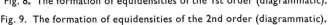

Fig. 8 Fig. 9

Fig. 8. The formation of equidensities of the 1st order (diagrammatic).

Fig. 9. The formation of equidensities of the 2nd order (diagrammatic).

The process of formation of the equidensities is as follows: In Fig. 8 the intensity I is plotted logarithmically on the abscissa axis and the resulting density D is plotted on the ordinates axis. For a given value of γ the characteristic curve N is obtained for the negative, and the curve P for the positive, whilst the combined negative and positive results in curve $N + P$, in which the well-defined minimum density is conspicuous and occurs approximately at places of equal density in P and N. Curve $N + P$ defines the equidensities, i.e. those places of equal density, which, lying either separately or linked together, are taken from the previous figures. The fourth curve in the figure represents a copy of $N + P$. The process can of course be repeated and the resulting copy combined again with $N + P$, thus producing "equidensities of the 2nd order". Thus Fig. 9 shows three characteristic curves: the continuously ascending curve of the original, that of the equidensity of the 1st order with one maximum and that of the two equidensities of the 2nd order (two maxima) can all be identified. The decrease in intensity becomes more rapid in passing from one order to the next. Figure 10 serves to illustrate equidensities of the 2nd order: they have been obtained from Fig. 6 by superimposing the negative and the corresponding transparent positive of Fig. 7 and making a print of this combination. The smallest surface details which are then visible are of the order of 30 Å, i.e. $\lambda/200$, which corresponds approximately to the degree of accuracy achieved by *Tolansky* (1948) in his measurements with the multiple-beam method. Here it must be mentioned that an interference fringe is described by two or four equidensities respectively, whereas in the multiple-beam method, only

16

one curve can be used for the surface analysis. Thus considerably more surface elements in the test material are recorded, and the maximum amount of information can be extracted from the photographs. Only in certain conditions is it expedient to continue the process to obtain equidensities of still higher stages, since one may

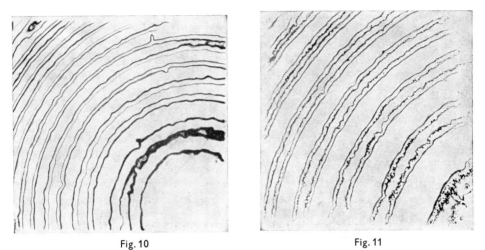

Fig. 10 Fig. 11

Fig. 10. Equidensities (2nd order) of Fig. 6.

Fig. 11. Equidensities (3rd order) of Fig. 6 (magnified section).

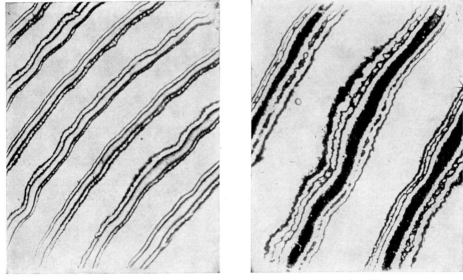

Fig. 12a Fig. 12b

Figs. 12a and b. Equidensities of higher order in the region of statistical grain variations (magnified section).

get into the region of statistical grain variations, and the visible granularities of the equidensities can no longer actually be involved (see also section 3.1.4). This is illustrated in Figs. 11 and 12 by reproductions of small sections of isodensities of the 3rd and higher order.

3.1.2 THE ONE-LAYER METHOD

3.1.2.1 *The Sabattier effect.* Certain difficulties are encountered in the method of positive-negative combinations discussed in detail above, since, on the one hand, a great deal of patience is required to bring the two components into really perfect alignment, and on the other hand, the two superimposed layers are always a small distance apart, and this gives rise to errors in copying. Therefore an attempt was soon made to obtain the negative and positive on the same layer, for which object the *Sabattier* effect affords a good foundation (*Arens,* 1949, 1950). By the *Sabattier* effect is understood the photographic reversal effect which is observed during the following procedure. An exposed plate is developed for several minutes and then given a diffuse re-exposure. It is then developed again for a short time until the previous, as yet unblackened parts of the plate have attained a sufficient density. The result is a partial positive effect. These facts have been known for a long time but they have never been studied or considered in relation to equidensities. Thus *von Angerer* (1952) reported that in two treatises (1912, 1926) *Eberhard* had described dark places with light contours which occured when a plate lying in a developer was allowed to be fogged by too bright a safe-light. This phenomenon had already been observed a fairly long time ago by *Lau* when he brought a plate which had not been fully developed very near to a safelight in order to see certain details. This plate was discarded when it exhibited the remarkable contours. Many people will have had the same experience: the "spoilt" plate which contained both a positive and a negative can hardly ever have been studied more closely or given much consideration, otherwise it would be incomprehensible why this well known effect has not hitherto been employed for producing equidensities†.

The relation between density and exposure as represented in Fig. 13 gives clear evidence that the *Sabattier* effect can undoubtedly be used for our purposes. This is confirmed in practice. We use the *Sabattier* treatment for printing a plate. By suitable choice of the γ-value and printing exposure we are able to emphasize each density region in the primary plate by means of a minimum density in the second plate. The experimental results confirm that sharp equidensities can be obtained in a few steps by making use of the *Sabattier* effect (cf. also *Högner,* 1963).

This possible application stimulated interest in making a more detailed study of the *Sabattier* effect (*Kind,* 1954), with the object of obtaining further hints for carrying

† Articles on the theory and application of the *Sabattier* effect are also to be found in the foreign literature (e. g. *Pires Soares* and *Cordoso des Santos* 1952) the expression used in the English language is *solarization* or *quasi-solarization*. In practice the effect was used solely for photomontage purposes; (*Fehr* 1944, *Sharples* 1945, *Thiery* 1949, *Geraci* 1952); cf. the article "Photographik" by *F. Fiedler* (Photo-Magazine February 1953, p. 38).

out the equidensity method in practice. The *Sabattier* effect is evidently the final result of several part-effects, namely the printing effect, a certain chemical effect, and possibly others which have yet to be studied more closely.

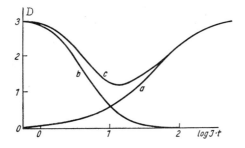

Fig. 13. Characteristic curves. (*a*) Primary density. (*b*) Additional density brought about by the Sabattier treatment. (*c*) The density resulting from (*a*) and (*b*).

The printing effect occurs because the silver which is formed during the first development protects the as yet undeveloped silver bromide which lies below and between the silver grains, from the second exposure. Thus the primary negative is printed in its own layer during the second exposure. After development, the positive which is thus produced, preponderates in the *Sabattier* region. The printing effect is admittedly quite considerable, but quantitatively it is insufficient on its own to account for the *Sabattier* effect.

The chemical effect causes developer to be used up at the exposed places during the first development, and the products of this reaction, e.g., KBr, undoubtedly inhibit development, to an extent which will be the less, the lower the primarily developed density. In the re-development which follows the second exposure, such silver bromide which is present in already primarily blackened surroundings is more or less protected from being reduced to silver. That the chemical effect is considerable is proved by the following experiment by *E. G. Kind*: this experiment gives in addition, quantitative data on how the formation of a secondary density is prevented by the reaction products resulting from the primary density. A plate is exposed under a grey wedge and then placed simultaneously with an unexposed plate in a developer dish. After developing the two plates for some time, they are then placed together with their sensitive layers in contact. The consumed developer distributes itself by diffusion on the exposed places in both layers. After a few minutes the plates are separated and given a uniform re-exposure. A little later the first plate shows of course the usual *Sabattier* effect, whereas a positive which is very much harder than could possibly be expected is obtained on the second plate. At those places containing exhausted developer, the second exposure has been practically ineffectual. Thus one has produced a positive effect on a plate in which the grains have been exposed perfectly uniformly. The effect is particularly marked if the plates are not returned to the developer solution after they have been separated, but are simply allowed to finish developing in the developer which has been imbibed by the gelatin. The desensitization

2*

of the photographic emulsion which is observed in this experiment in the relevant places, can be removed by washing. The effect observed depends solely on the presence of soluble products of reaction which act as restrainers. There is moreover a lower concentration of developer which has indeed already been partly used up in these places during the primary development. The exhausted developer is removed practically entirely by washing the unexposed plate thoroughly after contact (3 to 5 min are ample). Uniform after-exposure in combination with re-development is no longer able to produce a positive on the second plate. Corresponding experiments were also carried out later by *Klötzer* (1955).

The two effects which have been dealt with first, namely the printing and the chemical developer effects, have long since been brought forward in explanation of the *Sabattier* effect. However, the problem has not yet been solved satisfactorily. The printing effect has occasionally been cited as being mainly responsible for the phenomenon, and at times there was a tendency to believe that desensitization took place. The views regarding the nature of this desensitization are at variance. In some of them it is assumed that the phenomenon is brought about by the products of reaction of the developer. Since, however, the *Sabattier* effect can still be detected after the plate has been washed thoroughly, the printing effect appears to be essential in all cases. A possible explanation is that the products of the reaction are not completely removable by washing. This is, however, contradicted by the fact that the effect also occurs when a special developer (e.g., H_2O_2) is used, such a developer being unlikely to form reaction products which cannot be removed by washing. Another conception of the nature of the desensitization has been put forward by *Stevens* and *Norrish* (1938). In their opinion silver from the developing grains diffuses to the silver bromide grains and is deposited in the form of a finely divided precipitate, thus decreasing the sensitivity of these grains during the after-exposure and after-development. *Arens* (1949, 1950) recently postulated a theory for the *Sabattier* effect: this theory is based on the assumption of latent internal grain development. However, it is not our intention to go into this theory here.

Another experiment, and one which was carried out by *G. Roose* should be mentioned. Two plates were given a similar exposure through a grey wedge, and both were developed in the same manner. However, prior to the second exposure, one of the plates was washed thoroughly. Both the plates were re-exposed through the glass support. The washed plate did not exhibit any *Sabattier* effect, but only a uniform density, whereas the other plate showed the *Sabattier* effect. If, however, two such preliminarily prepared plates were exposed through their sensitive layers, both exhibited the *Sabattier* effect. In the case of the washed plate the printing effect might thus be proved to be essential. In producing equidensities it is often advisable to allow the printing effect to work on its own as much as possible. Among other things the chemical effects smooth out irregularities in the grains in the equidensity, but they can also give rise to slight displacements.

At all events, in summarizing the situation it can be said that the printing and chemical effects are essential for the *Sabattier* effect. Efforts have not been lacking to discover additional part-effects, but up to the present they have not provided a

satisfactory solution of the problem. It seems however not entirely unreasonable to suppose that the primarily developed silver grains may exert a restraining influence on the development of the grains which have been given an re-exposure.

3.1.2.2 *Other photographic effects.* The *Sabattier* effect is a partial reversal effect which takes place by the blending of a double-exposure effect with a developer effect, and is eminently suitable for the production of equidensities. *Gerth* (1965) and *Kröber* and *Gerth* (1964) have also studied the possible use of a number of other photographic effects for producing equidensities. Apart from a few other effects which would hardly be considered for practical purposes, the solarization and *Clayden* effects should be useful for many objects.

In the case of the solarization effect (in contrast to the *Sabattier* effect), the extreme value occurs in the form of a maximum which is moreover very wide. *Werner* (1962) showed that solarization equidensities could be reproduced satisfactorily provided that certain photographic materials were used (e.g., Agfa Direkt Duplicat Rapid).

The *Clayden* effect is purely an exposure effect which occurs when an extremely short, high-intensity first exposure is followed by a longer second exposure of low intensity. The developable density is thus decreased, and a minimum density, which however is much more shallow than that obtained with the *Sabattier* treatment, makes its appearance. According to *Gerth, Clayden* equidensities can be reproduced very well and are particularly suitable for the production of families of equidensities (see section 3.1.4) for obtaining equidensities of the first order. When equidensities of higher orders are being produced one should commence with the wide *Clayden* equidensities and change over to the sharper *Sabattier* equidensities.

3.1.3 THE INFLUENCE OF THE γ-VALUE. A very important question is the influence of the γ-value of the plates, i.e. their grade of hardness or softness, when aiming to achieve perfect equidensities. γ is a measure of the gradient of the characteristic curve, the harder emulsions always possessing higher γ-values than the softer emulsions. If the characteristic curve is inclined at an angle of α to the abscissa axis, then $\gamma = \tan \alpha$, that is, the definition of the equidensities is dependent on the γ-value of the photographic material. With materials of low γ-value, wide equidensities of poor definition are obtained, whereas with materials of high γ-value, sharp narrow lines are produced. These facts were soon noticed and as time went on could be brought under practical control.

If we first take ideal characteristic curves as a basis, then the conditions for producing equidensities of certain densities by using a negative and a positive are as follows: (Fig. 14).

Let a range of densities, say a grey wedge, be defined by a gradient γ_1, and let this be printed on to photographic material of gradient γ_2, thus producing a positive of gradient $-\gamma_1\gamma_2$. If both these components are brought into exact register, then on viewing by transmitted light, an equidensity, one side of which has a gradient of γ_1 and the other a gradient of $\gamma^* = \gamma_1\gamma_2 - \gamma_1$ is obtained. In general the equidensity will

thus be unsymmetrical (the degree of asymmetry being dependent on γ_2), and the depth (definition M) will depend on the secondary exposure and on γ_2. If positives of various grades of hardness γ_2 produced from a grey wedge negative of γ_1 are used, then M moves along the characteristic curve γ_1.

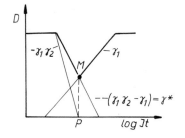

Fig. 14 The formation of a photographic equidensity.

It is of interest to note that point M which defines the depth of definition of an equidensity has the same abscissa co-ordinate as the point P at the foot of the D curve of the positive, i.e. (always starting from the grey wedge) the maximum definition of the equidensity is in the same position as the threshold of the 2nd component. This only holds for these ideal curves: if, as is actually the case, the value of γ_2 decreases continuously until the threshold value is reached, then the position of the equidensity will be that in which $\gamma_2 = 1$.

Since there are various ways of exposing the 2nd component, for a given value of γ the equidensities can be placed in different D-regions (Fig. 15a).

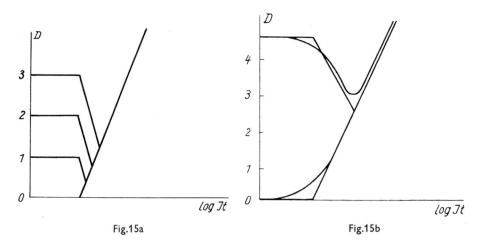

Fig.15a Fig.15b

Fig. 15a. Equidensities in different density regions.

Fig. 15b Comparison of ideal and actual curves.

22

If we now digress from the photometric wedge, then the various γ_1 values drawn in Fig. 16 define the different gradients which are present in an image, and to which different γ_2 gradients in the respective positive correspond, thus resulting in different values of γ^*. The equidensities (a, b, c, d) which are formed are all of the same density and only differ in width corresponding with the gradients in the plate in question. The depth of definition depends on the characteristic curve of the positive, i.e. on γ_2: when $\gamma_2 = 2$, symmetrical equidensities are obtained, because in this case γ^* becomes equal to γ_1. In practice it is therefore important to choose γ_2 as accurately as possible.

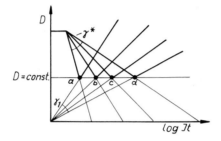

Fig. 16. Density gradients and equidensities.

Photographic equidensities in all their variety have been described by *Krug* (1958). The results can, without hesitation, also be applied to the one-layer method. Thus it is only possible to use the above-described conditions to control the equidensities if the characteristic curves are known precisely. For the primary exposure a straight-line characteristic curve is desirable in order to place the equidensities in previously specified regions. However the characteristic curves of commercial plates are S-shaped, and this presents considerably greater complications in localizing the equidensities, both as regards the slope at the sides as well as the position of point M (Fig. 15b). Thus it was necessary either to apply previous considerations to normal plate conditions and thereby arrive at considerably more obscure relations, or else to search for the kinds of plate which conform with to the simple relations dealt with above. A basis for the latter possibility is afforded by the investigations of *E. G. Kind* (1959) on the preparation of single-grain layers from standard emulsions. The properties of contrasty plates are greatly altered by dyeing them with given concentrations of dyes of suitable spectral absorption: amongst other things, this results in less diffusion halation, and thus better resolution is obtained. The steepness of gradation can be reduced considerably, whilst the threshold sensitivity remains unchanged. By this means, at a low γ, a plate which can act as an intensity "snatcher" is obtained. For our purposes it is of decisive importance for the characteristic curve of the dyed plate to be a very straight line, as can be seen from Fig. 17. The plate is dyed in aqueous dye solutions. The dye concentrations as determined by *Kind* for the individual curves are approximately:

23

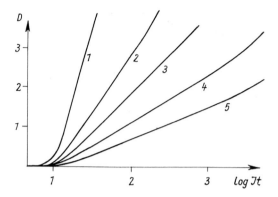

Fig. 17. Lowering the γ-value by dyeing the layer.

Curve	γ	True light orange GX	Anthralan yellow
1	8	0%	0%
2	3	0·25%	0·31%
3	2	0·5%	0·63%
4	1	1%	1·25%
5	0·8	2%	2·5%

The concentrations depend among other things on the swelling power of the gelatin and the duration and temperature of the bath.

An ORWO Printon plate is used as the starting material. This plate has a γ of 8, and it should be noted that filtered light, using a filter combination of GB 12 + GG 13 + GG 15 must be employed in order to obtain curves of extremely good linearity: filtering the light ensures that only those parts of the spectrum with equal absorption coefficients are operative.

The dyeing process thus enables plates with largely straight-line characteristic curves and of any γ to be produced and used for the production of equidensities in the desired density range. The position of the equidensities is then only dependent on the length of the second exposure. Since the dye is dissolved out during development, γ_2 is again high, and with the *Sabattier* process good equidensities are obtained in spite of the low γ_1.

Kind's method cannot however always be used. Precise knowledge of the characteristic curves of the negatives employed shows that the equidensities of astronomical objects have been placed in the correct positions (6.2.3).

3.1.4 EQUIDENSITIES OF HIGHER ORDER. A special problem arises in producing equidensities of a higher order by means of the *Sabattier* effect, namely that of obtaining equidensities which are distributed as uniformly as possible over the entire field of the image. If the work is commenced with hard plates (plates of high γ-value) the equi-

24

densities will be narrow and therefore those of the 2nd order will lie too close to each other. This is illustrated diagrammatically in Fig. 18a. If curve (*a*) is the intensity distribution, e.g., in an interference fringe, then when a hard plate is used, two steep equidensities (*b*) will be obtained: from the latter four equidensities of the 2nd order (*c*) are produced, each two of which will lie very close together. It would however be desirable to have the conditions illustrated in Fig. 18b: here the equidensities (*b*) are

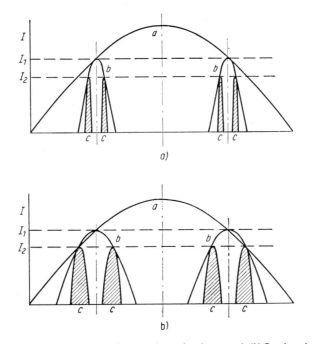

Fig. 18. Equidensities of higher order .(*a*) Produced on a hard material. (*b*) Produced on a soft material

wider, so that the four isodensities of the 2nd order (*c*) which are produced from them are distributed more uniformly over the entire intensity field, and above all, lie farther apart from each other. If attempts are made to achieve a wide equidensity by employing soft plates (i.e. plates of low γ), then the shape of this equidensity is found to be too flat and unsymmetrical and will not be suitable for proceeding to higher orders. The required results can however be achieved by decreasing the γ of the hard plate used for the first exposure to the desired value by dyeing the sensitive layer (see Fig. 17) by means of suitable chemicals; for instance, the γ of the plate can be decreased from $\gamma = 3$ to $\gamma^0 = 1\cdot5$ (Fig. 19). If the γ is equal to 3 in both the exposures, then the narrow equidensity A_1 will be obtained. If, however, the γ^0 of the plate is equal to $1\cdot5$, and the re-exposure is made at a γ of 3 after the dye has been washed out of the plate, then the wide equidensity A_2 will be obtained: this has about the same depth as A_1, but differs from the flat and unsymmetrical equidensity A_3 which actu-

25

ally belongs to $\gamma^0 = 1\cdot5$ (re-exposure) in having a more symmetrical intensity distribution.

This process can be repeated several times if required, and in this way 3rd or 4th order equidensities which lie sufficiently far apart from each other to be evaluated accurately are achieved. This method is of paramount importance when making an exhaustive analysis of an image (see section 6.5).

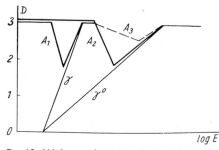

Fig. 19. Wide equidensities obtained by dyeing.

A simpler way of reducing γ is by the use of the *Clayden* effect (see section 3.1.2.2), or by means of holocopy (*Lau*, 1963, 1964, 1965).

3.1.5 THE SHARPNESS OF EQUIDENSITIES, AND INFORMATION CONTENT. From the foregoing statements it might appear that the aim should be to obtain equidensities of the greatest possible sharpness in order to achieve the highest degree of accuracy in the measurements. This is however only correct under certain specific conditions. In order to obtain the sharpest equidensities the tendency is to work with plates of the hardest possible grade, as demonstrated generally in the previous section. In an extreme case however, it may happen that the greater accuracy which is thus achieved in measuring over-sharp equidensities is only fictitious: the resulting equidensity is too narrow and follows the statistical variations in the grains without giving any information as to whether the limit of accuracy has been exceeded or whether the statistical irregularity has commenced. This is clearly demonstrated in the diagram given in Fig. 20. The density curve D_1 embraces an intensity region of ΔI which conveys

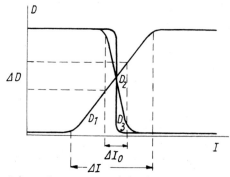

Fig. 20. The information content and the sharpness of the equidensities.

considerably more information than after reprinting on to extra-hard material of $\gamma_2 \gg \gamma_1$ (curve D_2). Here only the information (ΔI_0) contained in the region ΔD is reproduced. The equidensities will thus have a very sharp and a flatter side. In the case of a material with the extremely steep gradient of $\gamma_3 = \infty$ (curve D_3) there can be no question of an equidensity: it would have to become very narrow and unsymmetrical and the information content would become very slight, since $\Delta I = 0$. In spite of this, however, a curve is obtained by means of the scattered-light effect. In cross-section this curve is no longer controlled by a density gradient D, and in any case it produces scarcely anything more than a hard print. This effect has already been employed in photomontage (*Croy*, 1950). If the equidensity is wider and is controlled by a certain real density region, then, among other things, the degree of agreement between the structure of both the sides will give an indication of the actual feasibility of these practical measurements. Moreover, the width of the equidensity gives additional information on the particular gradients in the primary exposure. With the *Sabattier* method, and development to the same γ, the width of the equidensity is inversely proportional to the square root of the gradient. It is therefore advisable to choose plates which are suitable for dealing with this problem.

3.1.6 THE SCATTERED-LIGHT METHOD. Equidensities can also be produced by making use of the fact that the scattered light which is produced in a photographic emulsion and which passes out through the back of the material, has a maximum in the medium densities. Low densities produce very little scatter due to the lack of scattering centres (*Lau* and *Johannesson*, 1933), whereas high densities allow very little light to pass

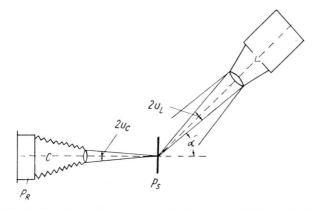

Fig. 21. Experimental arrangement for the scattered-light method.

through and thus scatter it only slightly, although the amount of light scattered is relatively large. The maximum lies somewhere between the two. *Schulz* (1953) in particular has investigated this method, the basis of which is as follows. If a photographic plate P_s (Fig. 21) is viewed by light which passes obliquely through it from the side (dark-field illumination) the places of very low density appear dark, because

they do not contain any silver grains which (by reflection and diffraction) scatter light into the eye. Likewise the places of very high density naturally appear dark, whereas those with a given average density of D_s appear the brightest. On the one hand the number of silver grains is not yet sufficient to prevent any light from being transmitted, and on the other hand, there are already sufficient silver grains to cause enough light to be scattered into the eye. If the latter is replaced by a camera, curves of varying width (equidensities) representing those places in the scattering plate P_s at which $D = D_s$ will therefore have to appear on the plate P_R in the camera. The details of the arrangement employed were as follows. The light source L consisted of a projector with a 250 W incandescent lamp, and the transparency in the projector was replaced by a ground-glass screen. Light from L was incident on the scattering plate P_s at an angle of α in dark-field illumination, and thus an image of P_s was formed by the lens of the camera C on the plate P_R on which equidensities of P_s then appeared. The emulsion side of P_s was turned towards the camera. The apertures u_L and u_C were less than 3°, and α was usually equal to 45°.

The physical basis of the scattered-light method is that function which represents the relation between the intensity J of the scattered light which gets into the camera C and the density D on the scattering plate P_s. It is very difficult to determine the form

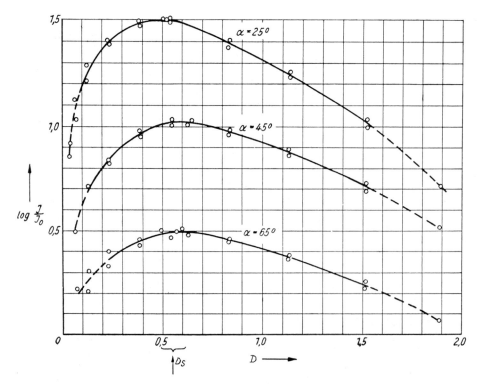

Fig. 22. Relation between the intensity of scattering J and the density D on the scattering plate.

28

of this function theoretically owing to the complexity of the scattering process. It was measured at various angles of incidence using *Agfa* Spectral plates (blue, extra-hard). The results of the measurements are shown in Fig. 22. The density D was measured on a *Zeiss* rapid photometer. The ordinates are plotted in the form of logarithms in relation to an arbitrary intensity unit J_0. The true distance between the three curves in the perpendicular direction is not reproduced in the figure, i.e., the curves may be regarded as being suitably displaced in the perpendicular direction. All three—within the limits of accuracy of measurement—are similar in shape but appear to flatten out somewhat with increase in α. These measurements do not reveal the existence of any perceptible relation between the angle and the position D_s of the maximum. According to this the maximum lies at a density of $D = 0.58 \pm 0.08$, which corresponds to a coverage of

$$\left(1 - \frac{i}{i_0} = 1 - 10^{-D}\right) \quad \text{of} \quad 73\% \pm 5\%.$$

The shapes of all the three curves are remarkably flat. Thus on the recording plate P_R (Fig. 21) they would be responsible for producing quite broad bands as equidensities if the photographic layer of P_R were soft or normal working. In order to obtain narrower and sharper equidensities it is therefore necessary to use a hard emulsion, and it is also expedient to print several times on to a hard material.

Figure 23 shows an interference micrograph of a section of a spherical surface. The distance between the bands is equivalent to a difference in height of $\lambda/2$ ($\lambda = 546$ nm).

Fig. 23. Interference micrograph of a spherical surface (incident light).

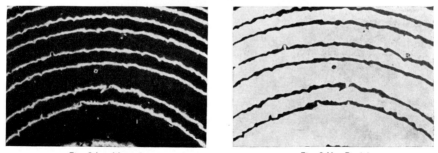

Fig. 24a. Negative Fig. 24b. Positive

Fig. 24. Scattered-light equidensities of Fig. 23.

Equidensities were produced from this photograph by the scattered-light method. The result is shown in Fig. 24a in which each of the wide black bands is seen to be replaced by two enveloping thin ones. Since it is easier to see equidensities which are in the form of dark lines, a negative print is shown in Fig. 24b. The considerable increase thus attained in the accuracy of the measurements in testing surfaces of this kind is evident.

A comparison with the results obtained with other photographic equidensity methods in sections 3.1.1 and 3.1.2 showed that the efficiency was about the same. An advantage of the scattered-light method in comparison with the other methods is that equidensities always represent the same density, namely that at which the intensity of scattering has its maximum value. On the other hand, its disadvantages are greater expenditure on equipment and higher sensitivity to the smallest impurities in the plate (cf., dust in dark-field illumination). The method has been used with great advantage in the photometry of large areas (see section 3.2).

3.2 *The photometry of large areas*

In the following a method (*Lau* and *Hess*, 1960, 1962) which gives a universal coverage of the intensity relations in two-dimensional photographs is described. This is linked up with a process which has been known for many decades, namely the screen process which is used particularly in the printing industry. It is not our intention to enter into the technical details of screen printing here, but only to state that this process enables intensity steps to be transformed into surfaces of different sizes which are capable of direct measurement. As the printing specialist knows, this screen process adapts itself extraordinarily well to the contrast range of an image. These conditions are demonstrated in Fig. 25. Figure 25a shows a fine-screen reproguction of a grey wedge which has been produced by the usual technique. Figure 25b dives a relatively coarse-screen reproduction of a negative of this grey wedge, an enlargement of which is finally reproduced in Fig. 25c, but with dark-field illumina-

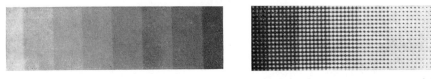

Fig. 25a. Grey step-wedge. Fig. 25b. Coarse screen-negative of the grey step-wedge.

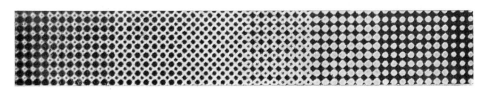

Fig. 25c. Fig. 25b with dark-field illumination.

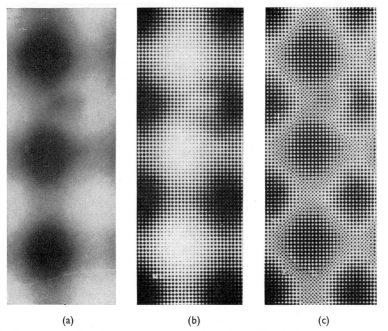

(a)	(b)	(c)

Fig. 26. The intensity distribution (a) is dealt with in (b) and (c) in the same way as in Fig. 25.

tion. The effect of the latter is to surround each of the blackened places with a brigh frame which occurs at a certain density of the slope of the edge (scattered-light equi-densities (section 3.1.6). Thus a distinct pattern which enables the individual densities to be very easily discriminated is formed. Figure 26a shows the intensity distribution of Fig. 34 which has been reproduced by means of a coarse screen (Fig. 26b) and by the same coarse screen in a dark field (Fig. 26c). Figure 26c shows the ease with which the individual grey steps can be discriminated. In particular, a kind of curtain pattern stands out: this occurs when 50% of the paper is covered by black places. This method can be employed not only for discriminating the individual densities, but it is also excellent for observing gradients and thus for obtaining a reliable picture of the entire intensity distribution (see also section 6.2.3).

3.3 *The density-relief method*

If one proceeds from the fundamental principle that an exposed and developed photographic layer represents a kind of relief consisting of reduced silver grains, one arrives at an equidensity method which differs basically from the dioptrical-photo-graphic one previously discussed (*Lau* 1958, *Lau, Kind* and *Roose*, 1958).

The density is dependent on the quantity of silver reduced: if the quantity of silver in some form or other can be measured locally, it must be possible to deduce the local density from these measurements. For measuring higher density values ($D > 2$) a

method of this kind would offer considerable advantages over the photometry of transparencies (photometric density measurement).

A very satisfactory means of measuring the "silver relief" is afforded for example by interference images, the curves of which connect up places of equal level. When the photographic layer is viewed under an *interference microscope* or in any other suitable interferometer, densities are brought into distinct relief by the contour lines. An interference microscope is a combination of a microscope and an interferometer which can be set up in various ways. For the microinterferometric observation of reflecting objects it is possible to place either a very small *Michelson* interferometer between the microscope objective and the object (*Krug* and *Lau*, 1951) or else a microobjective in front of the two mirrors in a *Michelson* interferometer (*Räntsch*, 1952, *Kohaut*, 1948, see also section 6.4.1). In each case an image is formed of one of the interferometer mirrors through the experimental object, whereas the other mirror acts as a kind of comparison mirror (e.g. a plane which is as perfect as possible). Such constructions enable conditions similar to those in ordinary interferometry to be obtained, e.g. in testing the flatness of optical surfaces: the conditions which are customary in the testing of surfaces must however be brought into line with those obtaining in a microscope in such a way that all the details which are capable of being resolved by a microscope can be incorporated in the test. Figures 27a, b and c show

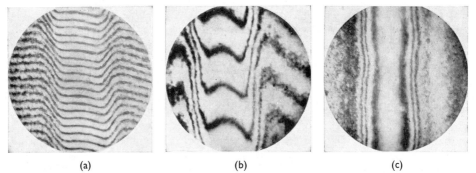

(a) (b) (c)

Fig. 27. The surface of a photographic emulsion (*Rienitz*, 1953). Width of the white band approximately 280 μm. Interference image: inclination of the plane producing the contour lines to the surface: (a) 21'; (b) 5'; (c) interference contrast image, so-called horizontal section.

an example of a section of the surface of a photographic plate on which an object-micrometer was photomicrographed. The light band in the middle of the pictures is the non-blackened image of a micrometer line of about 280 μm in breadth on the plate. The pictures on the left and right show the density of the surroundings. The figures show that the level of the non-blackened parts of the plate differs from that of the blackened parts: the latter lie at a higher level, so that the image of the line is a groove. In the present case the interference fringes can rightly be regarded as contour lines (obtained by cutting a section perpendicular to the surface). The main condition underlying the fact (in the case of the oblique section which is usually present in interference microscopy) that it is permissible to treat the resulting contour

32

lines as vertical contour lines, is that the contour does not alter appreciably, at least not over the region covered by the deflection of an interference fringe. The smaller it is possible to choose the angle of inclination between the surface and the planes produced, the greater will be the superelevation of the contour. The extent of the permissible region here is best seen from the interference contrast photograph in Fig. 27c in which small deviations in profile are more easily recognized than in the interference photographs (Fig. 27a and b). The latter however give a more direct impression of the contour than could be obtained from interference contrast photographs without using some method of evaluation.

The contour of the groove shows several unexpected features. It can be seen first of all from Fig. 27b that the edge of the groove has a somewhat elevated bank. Then follows a steep slope, whereas the middle of the foot of the groove again ascends slightly. The processes which are responsible for producing this curious profile during the treatment of the plate still remain to be investigated, as do also the consequences of this phenomenon. Undoubtedly disturbances are brought about here by the *Ross* effect†.

The most important finding resulting from studies of photograms of this kind is that the visible contour lines of the density relief in the interference contrast image (Fig. 27c) are to a large extent identical with curves of equal density, i.e. they represent equidensities.

The profile lines which are rendered visible by the density relief in the interference images (Figs. 27a and b) are more or less superelevated characteristic curves or photometric curves running in the same direction as the profile section. Accordingly, this interference image furnishes photometric curves in the case of *one-dimensional* photometric problems (e.g. in spectrophotometry, see section 6.3.1), and the interference contrast image yields equidensities in the case of *two-dimensional* photometric problems (e.g., in image analysis. See section 6.5). The prerequisite for the practical use of this method is an interferometer which has an adjustment which simply provides a means of constantly changing over from an interference image to an interference contrast image. An interferometer which has stood us in good stead in our experiments is the *Krug* and *Lau* interference microscope (1951): other interferometers or low power magnifying interference microscopes can also be used (*Schmidt*, 1959, *Hodam*, 1961). It might, however, be necessary for practical purposes to develop a kind of "interference magnifying glass" of low magnifying power in order to cover larger areas. Ordinary photographic plates are generally sufficiently flat over an area of about 1 cm² for them to be used in this method.

The advantages of the density-relief method are basically as follows. The interference image yields immediately the density curve even up to densities which cannot be covered dioptrically. Moreover, when the silver relief is fairly high, it immediately

† The *Ross* effect is a gelatin effect which is also dependent on the nature of the developer employed. Gelatin is hardened to various extents in the blackened places by developer oxidation products: these places dry more rapidly than the clear ones, and moreover, contract (*von Angerer*, 1952). [Cf. also F. E. *Ross*, Astrophys. J. **52**, 98 (1920), **53**, 349 (1951), Altmann 1966.]

yields families of equidensities which can be placed in any desired positions by means of a simple adjusting device. In addition, the families of isodensities or contour lines permit the density gradients to be read off directly at any desired position in the photogram.

The accuracy of the method depends on the properties of the gelatin layer (*Ross* effect and the smoothness) which influence the definition of the position of the fringes. By means of processes similar to those used in the production of high-gloss papers it is possible to obtain materials which are capable of giving very good interference fringes. *Schmidt* (1959), who has used this method with great success with stellar spectra, has made some very important suggestions on this subject (section 6.3.2).

With plates of medium hardness (spectral plates), e.g. one order of interference corresponds to $0.7 D$ in the straight-line region of the characteristic curve. Since an interference fringe can be localized directly to within 10%, it is not difficult to determine the densities in a region of three density units with an accuracy of up to $0.1 D$. If the fringes are sufficiently well defined, use can be made of the dioptrical-photographic equidensity method for further evaluation and for achieving greater accuracy.

3.4 *Colour equidensities*

Methods have already been suggested for improving the recognition of detail in photographs by preparing multi-colour images instead of black-and-white images (*Eichler*, 1958). In this way different intensities are reproduced in different colour values, and thus a larger number of differentiable steps in detail or in intensity between the two limiting black-and-white values is given than in the case of neutral grey values. This is because the colour-efficient eye is about 30 times more sensitive to colour contrast than to differences in brightness. Such methods have already been employed in radiography as well as in the reproduction of electron-microscope images (see, e.g., *Yotsumoto* and *Ito*, 1950 and also *Locquin*, 1950 and *Anderson*, 1950).

Whilst the object of black-and-white equidensities is to bring out a single photographic density in the form of sharp ridged lines in which process most of the pictorial relationship is lost, multi-coloured equidensities are of an integral, topographical nature, i.e., from each photograph they reproduce each intensity or density in a shade of colour which is assigned to it alone: thus the entire image is brought into effect, but the density steps do not stand out as absolute ridges. Either the usual one-layer original negative itself, or better still, a transparency of suitable, usually of hard gradation is used for making the reproduction.

Kankelwitz's method (see references to patents in the index) is based on the fact that a grey wedge can be converted into a multi-coloured wedge containing almost any sequence of colours. This method stems from an earlier discovery that, during the primary development, the density in a wedge builds up in the shape of a fan, i.e., the higher densities penetrate more deeply into the emulsion than do the lower densities. The secondary development (development after rehalogenization) proceeds parallel to the surface of the emulsion. This is illustrated diagrammatically in Figs. 28a and b

34

in which S is the emulsion support and E, the photographic emulsion. If one starts with a fixed black-and-white image, then after total rehalogenization the material is colour developed, commencing with yellow and fully developing with blue (Fig. 28c): this results in two monochromatic parts in the wedge, which, in transparency, give a sequence of colours ranging from white, through yellow and green to cyan.

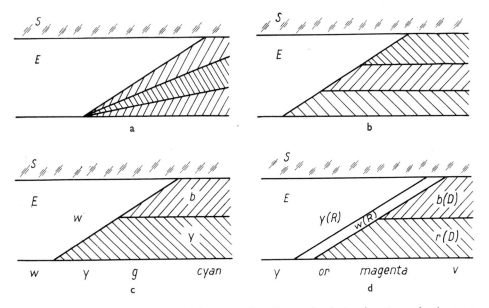

Fig. 28a. Fan-shaped construction of the density produced in a wedge during the primary development. E = emulsion; S = emulsion support.

Fig. 28b. Parallel construction of the density obtained during the secondary development of a wedge

Fig. 28c. Colour differentiation by means of two monochromatic parts: yellow (y) and blue (b).

Fig. 28d. Colour differentiation by means of two monochromatic parts in the parts obtained. D by the direct method; R by the reversal method.

By means of this simple method the grey step wedge (a) shown in Fig. 29a is converted into a colour step wedge (b). It can be seen in particular that the shading right up to the region of higher intensity is better than in the grey image. It is however also possible to choose a different sequence of colours for this process. If the aim is to obtain a colour scale which is better adapted to the spectral sensitivity of the eye, then the process which is represented diagrammatically in Fig. 28d and in which it is necessary to start with an unfixed black-and-white image, is used. A direct image which is divided into two monochromatic parts (red D and blue D), is first obtained. This is partially fixed (white (R)) and the plate is then exposed, thus rendering the hitherto unexposed part of the wedge still developable. Development of this reversal image is carried out e.g., by yellow colour development. The reversal image

(yellow (*R*)) together with the (*D*)-layers in the transparency gives a sequence of colours ranging from yellow, through, red and purple to violet.

The grey step-wedge (a) in Fig. 29 has been transformed into a multi-coloured step-wedge (c) by the multi-stage colour development process just described.

Special tricks can be used to obtain an "abrupt" colour differentiation within the range of colours covered by the multi-colour conversion: i.e., 3 large colour steps are formed in the sequence yellow/red/blue, in which the colour steps in density and tone are hardly differentiated, and between which again the two yellow/red and red/blue boundaries form the actual equidensities which appear to be sufficiently sharply demarcated on account of the colour contrast effect, and differ from the black-and-white equidensities in forming two different density lines, and do so moreover without loss in pictorial coherence. An example of this is to be found in Fig. 30.

The methods were first described by *Kankelwitz*, *Krug* and *Lau* (1962), and have already been employed in X-ray diagnosis (*Rakow*, *Angerstein*, *Krug* and *Kankelwitz* (1961), and by *Angerstein*, *Krug* and *Rakow* (1964). Colour developed aerial photographs of forests enable the individual species of wood to be identified when the grey values produced by the transmission and reflection coefficients which are characteristic of the foliage, are converted into colour values (*Krug*, 1964).

PLATE I

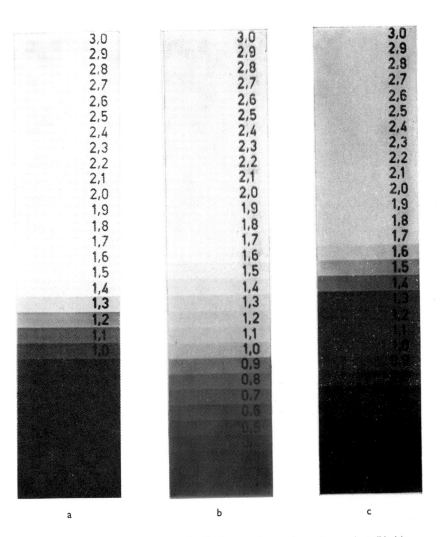

Fig. 29. Conversion of a gray wedge (a) into various colour step wedges (b), (c).

PLATE II

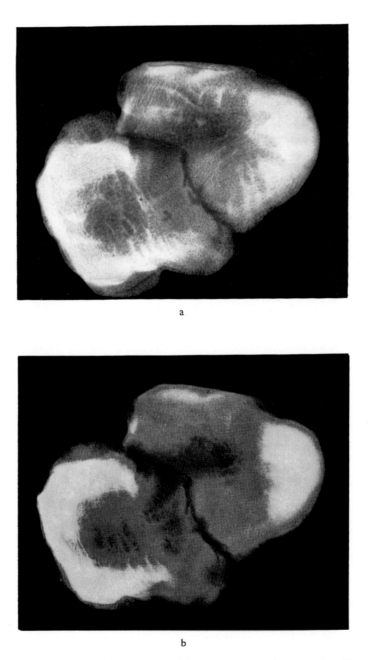

a

b

Fig. 30. Conversion of a radiograph (a) into a colour equidensity image (b).

IV. PRACTICAL PRINCIPLES

4.1 *General considerations*

The practical production of equidensities by means of the density-relief method is based on known interferometric methods of testing surfaces, and therefore does not need to be considered in detail here, particularly as a great deal of work on this subject has been published in the relevant literature (*Kohaut*, 1948, *Krug* and *Lau*, 1951, *Räntsch*, 1952, and *Dyson*, 1955, cf. section 6.4.1).

On the other hand, the conditions obtaining in the dioptrical-photographic equidensity method are quite different. In this case, at the present time, use has been made of new knowledge in scientific photography which could only be arrived at by means of equidensitometry.

In practice the *Sabattier* process has proved to be the most reliable and easily controllable method of producing dioptrical-photographic equidensities. According to *Kind*'s investigations (1959) and the special laboratory findings of *Hess, Stutzke* and *Roose*, both the two-layer method and the scattered-light method are less useful in practice, with the exception of the photometry of large areas (cf. section 3.2) for which the scattered-light method has proved itself to be extremely valuable.

Firstly the fact that the *Sabattier* effect is largely a printing effect makes it necessary to carry out the equidensity method with plates of high γ-value, making the reservations given in section 3.1.5.

In certain circumstances the chemical part-effect causes blurring of the finer structures by diffusion, and therefore it is usually advisable to wash the plates for a short time between the primary development and the second exposure. This will, of course, make the *Sabattier* effect somewhat less marked, but it will also result in more accurate rendition of the equidensities. Among other things the chemical effect compensates the irregularities in the curves, that is to say, it suppresses the smallest details. It is important to consider the accuracy and reliability of the method. It is first necessary to understand quite clearly that there are no lines of equal density in the true sense of the word, since density is, of course, a statistically variable quantity. The density owes its existence to the presence of black silver grains of finite size. The smaller the region being measured the more uncertain is the determination of its density, and variations occur in the densities obtained with equal exposures due to the statistical distribution of the grains.

Use of the equidensity method enables the equidensities to be refined to such an extent that the narrow region which is occupied by an equidensity can also be regarded as being uniform in density. Any further refinement is rendered impossible by the graininess of the photographic material. The equidensities degenerate into frayed images (cf. for example Figs. 12a, b).

Thus it can be proved that this method permits precisely that information which is presented by the position of the equidensities to be extracted from a given photograph.

Moreover it is only the graininess of the original plate which plays an important part in this respect, and not the subsequent plates with equidensities of the 1st and 2nd order, for the graininess of the primary plate is increased considerably on printing, due to the steep gradation of the photographic material which has to be used, so that the added graininess of the subsequent plates has to be neglected. This holds particularly when an enlarged print is made, a procedure which is very much to be recommended, since there is a greater certainty that in carrying out the various stages of the equidensity method, any effects which are conducive to a blurring of the finer details are no longer able to influence the results appreciably (cf. section 6.3.1).

4.2 *The production of dioptrical-photographic equidensities in practice*

To obtain the finest sharp equidensities of the first order it is necessary to have a really contrasty negative, otherwise the original has to be copied once or possibly twice on Printon, Ilford N 60 or similar photographic material to obtain an initial contrasty image. It is best not to make the copy by contact printing, but, in accordance with the previous remarks, by enlarging it. In producing photographs for photometric purposes, care must, of course, be taken to ensure that the entire field of the image is uniformly illuminated so as not to falsify the intensity relations (cf. section 6.3.1). This, however, is not so essential when it is purely a question of structure analysis (e.g., interferograms). From an original negative with very low contrasts only broad, frayed equidensities will be obtained (cf. section 3.1.3). The latter can, however, be improved by producing equidensities of the 2nd order.

In preparing equidensities from a given negative it is necessary to use an ultra-fine-grain photographic material which gives the maximum γ. Ordinary negative emulsions cannot be used because of their low contrast reproduction, so that recourse must be had to a technical photographic material which is usually of low sensitivity. The ORWO FU 5 phototechnical plate (Agfa-Printon) manufactured by the VEB film factory in Wolfen has proved to be the most successful one in these experiments.[†] It has an ultra-fine-grain emulsion of steep gradation and a resolving power of about 155 lines/mm. The spectral sensitivity of this plate lies approximately in the region of 400–480 nm. The speed of the ORWO plate is given as $-5\,S$ which corresponds to an increase in exposure time of about 10 times that of the "Hart" lantern slide plate (1 DIN). There is the additional advantage of being able to process the material in relatively bright dark-room illumination. Either of the ORWO safelight filters, 113 D (yellow-green) or 104 (orange) can be used. It is likewise necessary to use a vigorous developer for the development. Good results are obtained with the ORWO 75 developer prescribed in the ORWO book of formulae. Its composition is as follows:

Citric acid	5 g	Tripotassium phosphate	110 g
Hydroquinone	25 g	Potassium bromide	3 g
Sodium sulphite, anhydrous	40 g	Water to make	1000 cm³

† *A. Cosslett* (1965) recommends the Ilford N 60 photomechanical plate with a γ-value of 10. The developer used was either Johnson's "Maxi-Con" or Ilford's "High-Contrast" solution.

The developer has to be used undiluted. Should a flocculent precipitate be formed when tap water is used it must be removed by filtration. Use of the developer immediately after preparation should be avoided: to obtain uniform results it should be left standing for about one day.

It is not absolutely necessary to keep rigidly to this formula. Any ordinary commercial developer which gives at all contrasty results can be used, e.g., ORWO M-H 28 (Agfa metolhydroquinone developer) diluted 1 : 1.

The method of producing equidensities is as follows.

The original is exposed in an enlarger or in a contact printer on to the appropriate photographic material. It is advisable to make several strips with wide steps (cf. Fig. 31) of the same section of the image. The exposed plate is then developed for 1 min in the developer, using suitable dark-room illumination, and after excess developer has been removed from the material by thorough washing in running water (about $\frac{1}{2}$ min), the plate is then placed in a dish filled with water and given a diffuse re-exposure. This procedure has proved to be preferable to the one employed in the earlier experiments, in which the plate, after it had been washed, was exposed in the air, since, with this method any difference in the action of the light due to the drops of water remaining behind on the material is avoided. The re-exposure is expediently carried out by illuminating the room and ceiling respectively by means of opal lamps in such a way that the reflected light can strike the plate. Direct radiation may give rise to non-uniform light distribution and therefore to variations in the equidensities. The time of the after-exposure depends on the brightness of the room, the power of the lamp and its distance from the material, etc. and it must be determined for the conditions obtaining at the time. Let us give an example. In our tests a brightly lit room of 5 m × 5 m × 3 m in size was illuminated by two 100 W spherical lamps in the ceiling, thus providing an illumination intensity of about 28 lux on the plate, which, when correctly pre-exposed, made it necessary to give an re-exposure of 1–2 min. Subsequently to this second exposure the plate was further developed for 1–2 min to finality using the usual dark-room illumination, fixed completely, rinsed and dried.

It must also be pointed out that the after-exposure bears a definite relation to the printing exposure. By varying the first exposure, the positions of the equidensities, from the faint grey up to the deep black in the original negative, can consciously be shifted, resulting in a much wider equidensity in the pale grey than in the deep black region. The duration of the re-exposure must be adjusted to meet this situation: with a short pre-exposure a shorter re-exposure (often of a few seconds) is also necessary. The higher the density produced on the plate by the pre-exposure, the less critical does the handling of the re-exposure become.

The aim is for the pre-exposure and the re-exposure to produce about the same density on the plate. When making the test exposures, by comparing the regions of pre-exposure and after-exposure, it can easily be established which part of the exposure has to be altered. If the region of the first exposure is brighter than that of the second exposure, then it is possible either to shorten the re-exposure or to lengthen the pre-exposure, depending on where the equidensities should be situated.

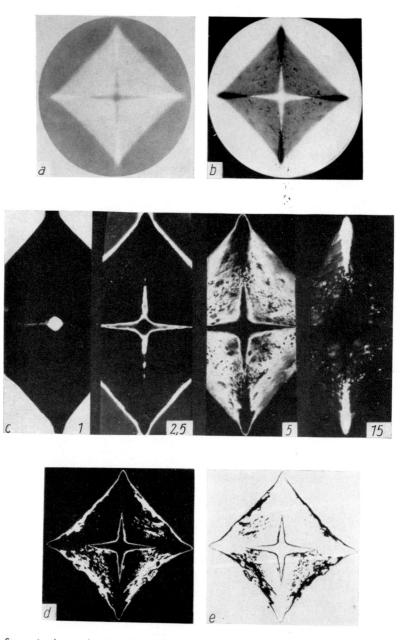

Fig. 31. Stages in the production of an equidensity. (a) Original. (b) Harder copy of (a). (c) Various tests made using times of 1, 2·5, 5, 15 for the first exposure. (d) Equidensities obtained with an exposure of 3·5. (e) Print of the equidensity.

If the equidensity lines on the final plates are somewhat blurred and are difficult to print, this difficulty can be surmounted by treating the wet plates with the following reducer:

Reducer ORWO 700

Solution A	Sodium thiosulfate	150 g
	Thiourea	12 g
	Water to make	1000 cm^3
Solution B	Potassium ferricyanide	20 g
	Water to make	1000 cm^3

For use, equal parts of A and B are mixed together. The plate is reduced by inspection, and then washed thoroughly. The made-up solution only keeps for 20 min.

It must also be pointed out that copying the original photograph makes it possible to produce equidensities of the 1st order which are just as fine and sharp as those of the 2nd or 3rd order obtained by the standard method of preparation. There is, however, the danger that the use of materials of steep gradation may result in the loss of certain details, or that one may move about on only one side and that there will be a decrease in the information content in spite of the very sharp appearance of the equidensities, as already discussed in detail in section 3.1.5. It is therefore not always expedient to force the sharpness of the equidensities too much.

If it is necessary to obtain several equidensities of different ranges of density from a single negative, the following method is recommended.

Several copies of high contrast are in the usual way produced by contact printing or in an enlarger. The exposures have to be varied in such a manner that the entire variation in the density of the negative is reproduced in the form of a graduated copy. In making the measurements it is useful to print a photometric wedge together with the negative. These copies are processed to give equidensities, possibly together, and giving an equal exposure time to obtain a high contrast material.

It is possible to put single equidensity films on top of one another and thus to represent the entire intensity distribution of the picture as viewed by transmitted illumination. In order to be able to discriminate the equidensities more easily from each other, they may be coloured in different toning baths or developed in different colours (cf. section 3. 4).

A. Rauch (1959) has used a method of obtaining families of equidensities (also directly on photographic paper) for evaluating smoke-streamer photographs. The unexposed material is soaked for about 2–3 min in the developer until the sensitive layer is completely saturated. The plate or paper is then placed under the material to be copied in an enlarger and given a short exposure. As soon as the development of the image is under way, a second exposure of twice to four times the length is given, and this may be followed by a third or fourth exposure of increasing length. This provides a convenient means of obtaining a family of 4 equidensities, but care must be taken to ensure that the emulsion does not dry completely, and that no displacement takes place. A limit is set by the fact that development already takes place during the exposure.

4.3 *The production of colour equidensities*

Any black-and-white film material of sufficient density and of not too low a γ is suitable for the production of colour equidensities. According to Fig. 28b, after rehalogenation, the colour image builds itself up in the form of discs, i.e. parallel to the surface of the film, and after 2 successive colour developments, forms smooth or abrupt colour echelons according to the gamma value. Flat negatives are best printed on to contrasty material (the negative having possibly been intensified beforehand), and these prints can be used for the colour development.

All colour combinations which, when superimposed, do not produce any grey tones are possible in theory. All the colour echelons which have hitherto proved successful cannot be quoted here. We shall therefore limit ourselves to the stages in the preparation of the colour wedges portrayed in Fig. 29.

WEDGE IN THE COLOUR SEQUENCE: WHITE-YELLOW-GREEN-CYAN (Fig. 29b)

In the dark:

5 min	black-and-white development
5–10 min	fix

then continue in the light:

5 min	wash
5 min	partially brominate 18 °C
5 min	wash
10 min	yellow development 18 °C
5–10 min	wash
10 min	chlorinate
5–10 min	wash
3–5 min	partial sulphite bath 18 °C
5 min	wash
10 min	blue development 18 °C
5–10 min	wash
5 min	brominate
5–10 min	wash
5 min	fix
10 min	wash

WEDGE IN THE COLOUR SEQUENCE: YELLOW-ORANGE-RED-VIOLET-BLUE (Fig. 29c)

In the dark:

5 min	black-and-white development
5 min	wash
3–5 min	partially chlorinate 18 °C
3–5 min	wash
5 min	red development ($^1/_5$ yellow $+$ $^4/_5$ magenta) 18 °C

Rinse (spray)

5 min	magenta development (addition of hydroquinone 0·3 g/l) 18 °C
5–10 min	wash
5 min	chlorinate
5–10 min	wash
3–5 min	partial sulphite bath 18 °C
5 min	wash
10 min	blue development 18 °C
10 min	wash
3–5 min	partial fixing bath 18 °C
5 min	wash and expose. Carry out further processing in the light
5 min	yellow development 18 °C
5–10 min	wash
5 min	brominate
5–10 min	wash
3 min	fix
10 min	wash

Both the instructions are standardized for laboratory conditions (development and washing in dishes). With machine processing the operations would take half as long. The material used was a technical film with a very steep gradient ($\gamma = 5$). When other kinds of film are used, the concentrations of the baths, especially of the partial baths, must be standardized for the type of film employed.

Composition of the baths:

Partial brominating bath: 5 g KBr + 8 g $K_3Fe(CN)_6$/l of H_2O
Brominating bath: 100 g KBr + 65 g $K_3Fe(CN)_6$/l of H_2O + 50 g Na_2SO_4
Chlorinating bath: 80 g NaCl + 80 g $K_3Fe(CN)_6$/l of H_2O + 50 g Na_2SO_4
Partial chlorinating bath: 4 g NaCl + 6 g $K_3Fe(CN)_6$/l of H_2O
Partial sulphite bath: 25 g of Na_2SO_3/l of H_2O
Partial fixing bath: 20 g of $Na_2S_2O_3$/l of H_2O.

Colour developer:

Part A: 1·1 g/TSS in 100 ml of water †
Part B: 2·4 g Na_2SO_3, anhydrous
1 g KBr
50 g K_2CO_3, anhydrous
in 900 ml of water

The respective colour couplers are added when A + B are mixed together.

Yellow colour coupler: 0·75 g of benzoacetanilide in 20 ml of dioxane
Cyan colour coupler: 0·75 g of α-naphthol in 10 ml of dioxane
Magenta colour coupler: 0·90 g of 1-phenyl-3-methyl-5-pyrazolone in 40 ml of alcohol

† TSS is the commercial trade name for $(C_2H_5)_2 \cdot NC_6H_4 \cdot NH_2 \cdot H_2SO_4$

V. INVESTIGATION OF THE EFFICIENCY
OF THE METHOD

5.1 *The reproduction of known intensity distributions*

It has first to be proved that the curves obtained by the processes described are in fact curves of equal density and that they thus effect a two-dimensional automatic photometering of a photographic plate. This can easily be demonstrated by investigating a known intensity curve by means of equidensities. This work was carried out in collaboration with *Rienitz* and *Roose* (*Lau, Rienitz* and *Roose*, 1953) who made thorough studies of the intensity curves of two-beam interference fringes. This intensity distribution is the basic phenomenon which constitutes the main spring of all interference optics and indeed of optics in general, and therefore the theory of this phenomenon will be considered briefly first of all.

Fig. 32a indicates two systems of plane coherent waves which are superimposed on each other. At point 2 on a plane drawn through a wave front of one of the two systems of waves the latter are said to be in phase, and thus at points 1 and 3 the waves are of opposite phase. By adding the amplitudes, a figure such as the one sketched in Fig. 32b is obtained. At point 2 the amplitudes are added together, thus producing

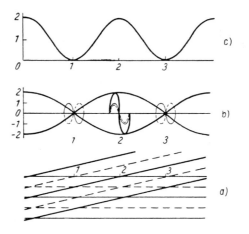

Fig. 32. Formation of two-beam interference fringes.

a bulge in the enveloping wave, whereas at points 1 and 3 (the nodes) the amplitudes are compensated. We are entirely incapable of perceiving the amplitude of an optical wave but can only observe the intensities. The intensity is known to increase with the square of the amplitude. It can be seen that the envelopes of the am-

plitudes form a sinusoidal curve. Since the intensity increases with the square of the amplitude we obtain the following equation:

$$I = \cos^2 \alpha = \frac{1 + \cos 2\alpha}{2}.$$

From this we obtain Fig. 32c which shows that the intensity distribution in two-beam interference fringes is cosinusoidal or sinusoidal, but that it possesses half the wavelength of the envelopes of the amplitude curve. The latter oscillates about the zero line, whereas the intensity curve corresponding to the squaring, only shows positive values.

Analysis of a two-beam interference fringe which is actually the foundation, has, to the best of our knowledge, only been made once (*Schult*, 1927). In this analysis, wedge interference patterns in reflection, which in essence represent two-beam interferences were used. The intensity relations were established by means of a micropyrometer. It seems to us to be expedient to produce two-beam interferences by means of a *Michelson* arrangement, since this gives the most clear-cut conditions. The one essential is to make sure that monochromatic light is used. However, in the neighbourhood of the zero order (light paths of equal length) the requirement of monochromasy is much less important if the lengths of coherence are maintained considerably greater than the path differences which occur (cf. also *Hund* 1951).

To make a photographic-photometric test of the intensity distribution of two-beam interference fringes, it is necessary to take a photograph of a two-beam interference system, and this photograph must be photometered with reference to the characteristic curve in as many places as possible. Use of the equidensity method leads to other possibilities of increasing the accuracy more rapidly than is possible with previously known methods. If equidensities are established from a single interference photograph, then a family of parallel curves which could be evaluated from a knowledge of the characteristic curve would be obtained. There is, however, always a certain degree of uncertainty in the use of characteristic curves, because it is never possible to establish whether the characteristic curve determined at another position in the plate also holds for the place undergoing measurement. In any case this kind of method gives rise to a whole series of errors in measurement. An equidensity method which does not require a knowledge of the characteristic curve was developed. This method is based on the following principle. If the same intensity distribution of interference fringes is photographed twice on the same plate which is turned through 90° for the second exposure, then an exposure intensity or density representing the sum of the intensities of both the systems of fringes at the places in question, is obtained at each place in the photograph. If equidensities are plotted by means of a photograph of this kind, then the shape of these equidensities will be given by the position in the interference system, and the intensity relations can be read off accurately from a family of equidensities. The details of this method are as follows: A two-beam interference system was photographed close to the zero order through an interference microscope. After exposure, the photographic plate was turned through 90° and again exposed for the same length of time. This

produced an interference system, the theoretical curves of equal intensity of which are drawn in Fig. 33, the maximum intensity of an interference system corresponding to Fig. 32c being put equal to 2. The place at which the intensity maxima of the two interference systems coincide, thus receives an intensity value of 4. The sinusoidal

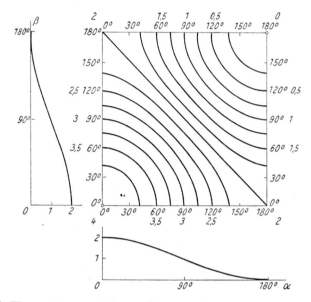

Fig. 33. Theoretical curve of the equidensities with crossed interference fringes.

intensity distribution of those parts of the interference fringes which overlap in the quadrants is shown on the lower left-hand side of the figure. Thus the equation of an equal intensity curve which must however at the same time be an equidensity is given by:

$$\cos \alpha + \cos \beta = \text{const.}$$

A family of equidensities of this form will only be obtained when the intensity distribution is sinusoidal. Thus the question arises as to whether the equidensities which are obtained dioptrically-photographically from these photographs are curves which coincide with these theoretical curves, and, if so, would provide evidence of the reliability of the method. Figure 34 gives firstly an enlarged print of the negative used, whereby it should be noted that the distance between two maxima in the original was about 4 mm. The image in the original is, however, less contrasty than in the reproduction. The method employed to produce the equidensities is the *Sabattier* effect (cf. section 3.1.2) by means of which Fig. 34 was reproduced on five plates with equidensities of the 1st order in which, by varying the times of exposure, the equidensities were placed respectively in different positions of increasing density in the original photograph. Figures 35 and 36 represent examples of two prints which

46

have been obtained in this way. Since the equidensities of the 1st order are still suffi-
ciently wide, the process can be repeated. Thus from a first equidensity, two equi-
densities of the 2nd order which run along the inner and outer sides of the first equi-

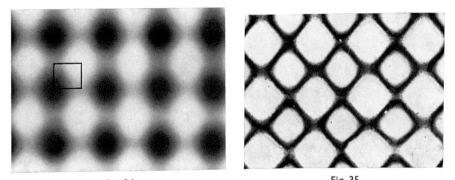

Fig. 34

Fig. 35

Fig. 34. Crossed two-beam interference fringes. (The intensity distribution of Fig. 33 prevails in the square).

Fig. 35. Equidensities of Fig. 34 (cf. Fig. 37).

density can be produced. This series of equidensities is fully illustrated in Figs. 37–41
Figs. 37 and 40 having been obtained from Figs. 35 and 36 respectively. Figures 37–41
all show the same section in the same position and enlarged to the same degree.
It can be seen that the equidensities produced in the second order are of considerable
sharpness, and that they can be used for making measurements, since their position
is sufficiently well defined. A special advantage of this method is that, on the entire
available surface, places showing deformations which are due to the experimental
conditions are immediately perceptible. These places are not included in the measure-
ments. Thus with this method it is not necessary to take the average of an immense
number of measurements since the best places for making the measurements can be

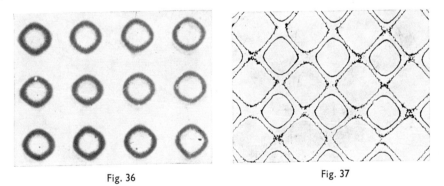

Fig. 36

Fig. 37

Fig. 36. Equidensities of Fig. 34. (cf. Fig. 40).

Fig. 37. Equidensities of the 2nd order (obtained from Fig. 35).

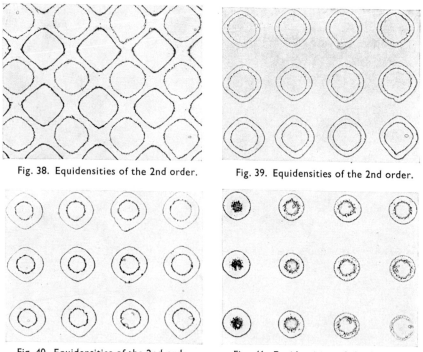

Fig. 38. Equidensities of the 2nd order.

Fig. 39. Equidensities of the 2nd order.

Fig. 40. Equidensities of the 2nd order
(obtained from Fig. 36).

Fig. 41. Equidensities of the 2nd order.

recognized immediately, and the other places are eliminated, not arbitrarily, but for a good reason. The local distortions in the equidensities can in essence be accounted for by faults in the reflecting power of the interferometer mirror and in the dioptrics, faults with which we have first become acquainted in this study and which cannot

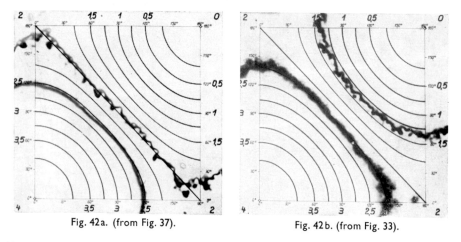

Fig. 42a. (from Fig. 37).

Fig. 42b. (from Fig. 33).

always be avoided. The equidensities obtained in Figs. 37–41 were projected on to the diagram in Fig. 33 and in this way prints of the diagram + the equidensity were produced (Figs. 42 and 43).

From these illustrations it can be seen at once how closely the photographic equidensities follow the theoretical contours. A remarkable feature is that the equidensity next to the zero value (top right-hand in each figure) is more grainy than the other

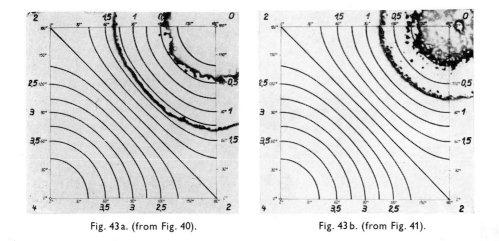

Fig. 43a. (from Fig. 40). Fig. 43b. (from Fig. 41).

one. This is connected with the fact that at the time when the pictures were being produced, the necessity of washing between each stage (section 4.2) had not yet been recognized. If a first equidensity is produced, then in this case the side of the contour produced by the re-exposure will be compensated by diffusion of the developer restrainer, thus decreasing the graininess. For this the graininess is not disturbing, since it is not a question of studying detail but solely that of the overall shape of the curve which is represented by some kind of automatic approximation to the mean value. Also the irregular curves of the other sides of the equidensity of the 1st order indicate quite clearly the position of the equidensities. These figures thus prove that the theoretical intensity distribution is reproduced with great accuracy. This signifies moreover that should the normal laws governing the relation between amplitude and energy hold in the case of light vibrations, the vibrations are sinusoidal, thus giving further indirect and exact proof of the accuracy of this theory. On the other hand, the photographs prove the excellence with which work can be carried out with photographic equidensities. The selected symmetrical curves which do not exhibit any local interruptions follow the theoretical curves very closely. Each individual equidensity already secures a large region of the sinusoidal intensity distribution. In any case there is no indication of any systematic deviation.

The equidensity method was, moreover, tested by producing another, a third order equidensity (Fig. 44) from Fig. 39. It can be seen that each equidensity of the 2nd order is split up again into two equidensities of the 3rd order. If the distance of the outer pair

4

of equidensities which has been obtained from the sharp 2nd order equidensity, is measured, then the distance between the lines is about 30% greater at the corners than in the straight-line part of this pair of curves. In theory the distance ought to be 40% greater. In this case the equidensities of the 3rd order have been shifted by an

Fig. 44. Equidensities of the 3rd order (from Fig. 39).

amount corresponding to about $^1/_{100}$ mm in the original photograph, presumably because photographic effects bring about a somewhat greater percentage broadening of the lines of the 2nd order at the narrow places, as compared with the wide ones. This could probably have been avoided if a greater degree of enlargement had been chosen. It can, however, be concluded from the photographs that equidensities of the 2nd order do not exhibit any substantial errors.

The equidensity method enables the density relations in an ordinary photographic plate to be evaluated in the same way as they are presented in the case in question by the photographic plate. Thus it must be noted in particular that an unequivocal relation does not necessarily exist between these density relations, which have already been influenced by optical image defects, by diffraction during the formation of the image, and by the scattering of light in the emulsion layer, etc., and the original. These factual observations come within the ambit of a separate set of problems and have no direct connection with the equidensity process itself, but they play a part in the interpretation of the final equidensity image, since, in certain circumstances, unjustifiable or erroneous conclusions may be drawn regarding the nature of the original. The interference fringes used in this investigation were not very contrasty. With very contrasty interference fringes special problems arise in the double exposure of photographic materials (cf. section 6.2.2).

5.2. Density gradient, resolution of detail and equidensities

If it is desired to test the reliability and accuracy with which the equidensities follow the places of equal density, due consideration must be given to the gradient.

50

In the family of curves in Fig. 16, the primary photographs are presumed to have a specific gradient. If the abscissae are extended the gradient becomes less steep and, at its reciprocal value, the equidensities spread out. The accuracy of the position of the equidensities does not, however, increase in proportion to the extension in one dimension, but only in proportion to its square root, since the variation in the number of grains decreases with the square root of the number of grains involved. It follows therefore that when the original is enlarged in two dimensions, the same image element will be reproduced, and will contain a number of grains corresponding to the square of the enlargement. The definition of the density of an image element accordingly increases with the enlargement. Thus as long as the equidensities are not made to take the form of extremely sharp lines (cf. section 3.1.5), but represent two-dimensional structures, the information content increases with the degree of enlargement. If, however, when the gradients are large, the equidensity appears as a sharp line, this must not deceive an observer. In this case the position of the equidensity does not always reproduce the density region accurately. Since, however, this case arises when images of sharp contours (profiles) are formed and the various densities lie quite close together, a satisfactory curve is nevertheless drawn: thus poor definition of density has only a slight influence on the local shape of an equidensity.

If all the curves obtained in the previous section are examined, it is seen that at certain density values the shapes of the two 2nd order curves are smooth, whereas at the other density values one of the curves is frayed. The explanation given is that the smooth curves lie in the region of optimum detail reproduction and also correspond to the higher gradients in the original photograph, whereas the frayed curves lie in the region of low detail resolution and where the gradient is low. Thus the local definition in density has an influence on the equidensities. It is moreover remarkable that even equidensities of the 3rd order enable another different intensity gradient, covering a region of $^1/_{10}$ mm in the original plate, to be recognized in the latter.

If a family of equidensities is produced from an image by means of equidensities of higher order (cf. section 3.1.4) or by printing different equidensities of this image on top of each other (cf. section 6.5), then the local compactness of the equidensities will give a measure of the gradient.

The electronic equidensity method (cf. section VII) may perhaps be especially suitable for obtaining any suggested families of equidensities.

If the gradients in the image are very low, as for instance in the photoelasticity photographs of *Schwieger* and *Haberland* (cf. section 6.7), very wide equidensities of the 1st order are formed, their width giving a measure of the gradient. The latter can be measured by measuring the distance between equidensities of the 2nd order. No useful purpose is served by making the curves of the 1st order thinner, as this results in the loss of information.

Fig. 49 gives a good impression of the shape of an equidensity with continuously changing gradients.

5.3 *The accuracy of the measurements*

The accuracy of the measurements made by the equidensity method has not as yet been thoroughly investigated. Communications on this subject have been chiefly to the effect that the experimental results have shown for example that no further refinement of the equidensities was possible once the region of statistical grain variations had been reached. The obvious inference is that with this particular photometric method a natural limit is reached, and the information value extracted from the photographic plate corresponds to that which is obtainable by point-by-point photometric measurement. Here again the accuracy of measurement is limited by fluctuations in density caused by the statistical distribution of the silver grains.

The equidensity method finally results in equidensities of the "last order", which is a system of more or less thin bands which can still be regarded as well-defined coherent bands. According to *Kind* there is little option but to assign a width of *b* to a band of this kind. It has then to be seen if this width *b* also corresponds to a theoretical value β, which, on the assumption of the statistical distribution of the silver grains—and the consequent uncertainty of the density value in small regions— is derived as the value which will convey the meaning of the width. If β were proved to be equal to *b*, this would demonstrate the width *b* of the equidensity to be the optimum attainable value.

Let us assume that we have a photographic plate with a specific density distribution, and let ΔD be the mean variation in density in a small area *A*. The relation between *D* and ΔD can be assumed to be†:

$$(\Delta D)^2 = \frac{a}{A}(0 \cdot 5D + 0 \cdot 15D^2)$$

in which $a(\ll A)$ signifies the average area of a single silver grain. An uncertainty of ΔD in the position of a specified density value in the direction of the density gradient can be assigned to this uncertainty Δx in the density in a specified position in the plate. The relation between ΔD and Δx is given by

$$\Delta D = \frac{\partial D}{\partial x} \cdot \Delta x$$

into which the density gradient $\Delta D/\partial x$ enters.

We shall now give a plausible definition of the minimum width β of a band which can still be regarded as being of uniform density, such that the average uncertainty of the position Δx of a small area *A* of dimensions β^2 constitutes one tenth of β, that is to say

$$\Delta x = \frac{1}{10}\beta,$$

$$\beta = 10\,\Delta x; \quad \beta = 10 \cdot \Delta D \cdot \frac{1}{\dfrac{\partial D}{\partial x}},$$

† On the basis of theoretical considerations of the stratification and overlapping of layers of gains, *Kind* has completed this equation by the addition of a quadratic member which, in the nature of things, only takes effect at higher densities.

$$\beta = 10 \sqrt{\frac{a}{\beta^2} (0 \cdot 5D + 0 \cdot 15D^2) \cdot \frac{1}{\frac{\partial D}{\partial x}}},$$

$$\beta = \sqrt{10 \cdot \sqrt{a} \cdot \sqrt{0 \cdot 5D + 0 \cdot 15D^2} \cdot \frac{1}{\frac{\partial D}{\partial x}}}.$$

Extensive experiments have shown that b and β are actually equal in magnitude. Numerical example: Say that the photograph of a system of interference fringes is studied by the equidensity method. The distance between the bands, $B = 4$ mm: $D = 1$; $\partial D/\partial x = 1 \cdot 8$ mm^{-1}; $\sqrt{a} = 1$ μm. From this it follows that $\beta = 67$ μm, thus $\beta : B = 1 : 60$. Thus an equidensity in the region of the given gradient is established to the nearest sixtieth of the distance between the fringes. If a surface is being tested, then according to this, roughnesses in the surface of up to $\lambda/120 \sim 40$ Å can be determined ($\lambda = 0 \cdot 5$ μm), always assuming of course that the resolving power of the interference microscope employed is sufficiently high to resolve points which are situated at a distance of 67 μm from each other in the photographic image. Assuming the relation $d = \lambda/A$ for the resolving power (d is the distance between just separable points and A is the numerical aperture of the microscope), then with a magnification of 33 times and an aperture $A = 0 \cdot 25$, the assumption is still fulfilled. Thus care must always be taken to establish beforehand whether, on account of the fine-graininess of the photographic material, any useful purpose will be served in attempting to improve the equidensities by means which are possible in certain circumstances. The limit of 40 Å in this special case holds for an element of β^2 in the surface. If the shape of the equidensity is expected to be a smooth line, then the position of the latter is defined by a large number of points, and thus considerably greater degrees of accuracy are attained. Thus, e.g., in estimating the thickness of evaporated layers or of steps in crystals the accuracy of the measurements reaches about 10 Å, a value which can already be arrived at by taking the average of only 16 such observed β^2-elements. It can thus be seen that the value of 10 Å by no means represents the lowest limit in principle. It follows from the equation for β that this value is dependent on the density D and the gradient $\partial D/\partial x$, i.e. with a low density and a large gradient a minimum occurs. This minimum is at the same time the optimum detail reproduction. It appears from Figs. 42 and 43 that Fig. 42b shows both the curves well traced. Here we find ourselves in the region of the best detail reproduction, i.e., the information content is a maximum. The considerable amount of distortion shown at present by the other curves in the remaining figures is attributable to variations in the grain.

Hitherto ideally constant illumination was assumed. But the position of equidensities is affected by errors of illumination. If, for instance, equidensities are made from a two-beam interference photograph, these errors can falsify the results of the measurements. In this case the following method [*Schwider, Schulz, Riekher, Minkwitz* (1966)] is advantageous. The equidensities are not directly evaluated, but are averaged

in pairs, and the mid-lines are evaluated. Then the error $\Delta\zeta$ in the position of the interference maxima and minima is much smaller (see Fig. 45 with the following notations: D = density, p = position on the plate, R = real section of the density distribution by the equidensity $D = D_0$, J = ideal section of this density distribution, p_{ideal} = middle of p_n and $p_{n+1/2}$, p_{real} = middle of $(p_n + \Delta p_n)$ and $(p_{n+1/2} - \Delta p_{n+1/2})$, F = fringe spacing). The error $\Delta\zeta$ if the equidensities are situated approximately at the loci of greatest gradient of intensity is:

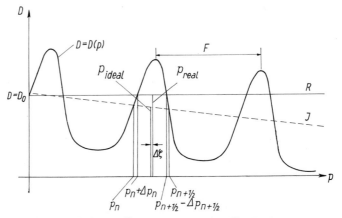

Fig. 45. Error $\Delta\zeta$ owing to inconstant illumination.

$$\Delta\zeta \approx \frac{F}{4\pi V} \ln \frac{A(p_n)}{A(p_{n+1/2})} \quad \left\{ \begin{array}{l} V = \text{visibility (contrast) of the fringes, } A(p_n) = \text{intensity at} \\ p_n, \, A(p_{n+1/2}) = \text{intensity at } p_{n+1/2}. \end{array} \right\}$$

If, for instance, $A(p_n)/A(p_{n+1/2}) = 6/5$, then $\Delta\zeta = F/70$. Such large errors $A(p_n)/A(p_{n+1/2})$, are however, easily detected and avoided.

5.4 *The Limits of equidensitometry*

In general it can be said that the definition of the equidensities ceases where the definite density ceases: a density cannot be termed a density until a sufficient number of grains participate in its formation. Wherever one comes across statistical variations in the grains the method ceases to be effective (cf. Fig. 12a, b). This is moreover a property of photographic photometry in general, i.e., the limit lies in the photographic emulsion. Sufficient examples of this have been given in the separate chapters.

Many authors have attempted to use the equidensity method for studies in which it is bound to fail. Thus, without taking special measures, it is incorrect to draw on this process for identifying the minimum or maximum in unsymmetrical intensity distributions, e.g., for establishing more precisely the position of interference fringes, spectral lines, or such like. According to the theories considered in the last chapter, the most suitable use of the method must be for those parts of the image with large gradients. It is not surprising, therefore, that individual researches into

methods of improving the evaluation of *Debye-Scherrer* diagrams (*Kleber*, 1956, *Hubrig*, 1964, *Schenk* and *Hubrig*, 1964) as well as general investigations made with a view to improving the position of the interference maximum (*Heinz*, 1960) did not meet with success. If, however, a sufficiently steep intensity distribution is superimposed on the spectral lines, interference fringes and the like, then equidensities which pass over the maximum and establish the position of the maximum with certainty, are obtained. *Werner* (1962) has, for example, formed an unsharp image of a pair of threads in copying *Debye-Scherrer* diagrams on to an equidensity plate. This resulted in a considerable improvement in the localization of the lines and gave a general idea of the intensity distribution (see also section 6.3.1).

VI. FIELDS OF APPLICATION

6.1 *General considerations*

According to previous work on the subject, the evaluation of interference lines can be named as an important field of application of equidensitometry. In particular, when testing surfaces it has led to an improvement of 1–2 orders of magnitude in the accuracy of the evaluation of interferograms obtained with an interference microscope. The advantage here is that the method is equally applicable to two-beam interference fringes and to multiple-beam interference fringes, as well as enabling each interferogram to be subsequently treated and evaluated.

A large field of application is in the automatic photometering of intensity distributions which are either blurred or continuous in shape such as those which are present in most photomicrograms. In the evaluation of over-enlarged photomicrographs the equidensity method renders additional details visible. For instance, photographs of *Pleurosigma* magnified 3000 times were made using an aperture of $A = 0.65$. After they had been equidensitometered, about the same details were identified as those which are normally still visible in photographs of the same object taken with oil immersion, i.e., using an aperture of > 1. The equidensities of the oil-immersion photographs already show up certain details which can only be obtained in the well-known electron-microscope photographs of *Pleurosigma*. Such photographs can, of course, only be taken if certain assumptions are made. The method is also applicable to electron-microscope photographs.

Another useful field of application appears to lie in the testing of profiles. A difficulty is experienced in forming contour or silhouette images with the aid of a microscope or a projector, because in most cases the resulting image is not sharply defined, and therefore cannot be measured accurately. This lack of sharpness is caused by irradiation, diffraction, thickness of the specimen, etc. (profile testing of threads of screws). If the equidensities of profile photographs are made, then the unsharpness appears to be eliminated, and the lost details are copied so that the profile stands out sharply and is rich in detail. Equidensities can also be used successfully for measuring and evaluating the profile images of surfaces by means of the light-streak method. Other possible uses may arise in the study of spectra and other physical problems (e.g., *Haas*, 1962, *Kröber* and *Gerth*, 1965, *Pohlmann*, *Bohnen* and *Brinkmann*, 1965, *Hubrig* 1962, *Gerth* 1967).

6.2 *Photometry*

6.2.1 THE PRODUCTION OF THE CHARACTERISTIC CURVE. An example of the use of equidensitometry for purely photometric purposes has already been given in section 5.1 on the study of the intensity distribution of two-beam interference fringes, and in such detail that the method described can easily be adapted to problems of a similar

nature. In these cases *two-dimensional* photometric evaluation of the entire surface has proved of particular value.

A special application of eqidensitometry has been suggested by *Schulz* (1953), namely for the production of the characteristic curve of a photographic plate without the aid of a photometer.

The characteristic curve of a photographic emulsion shows the relation between its density D and the log of the exposure Jt (J = intensity, t = time of exposure) with reference to the units J_0 and t_0. Curves of this kind are shown e.g. in Fig. 8 (curve N) or Fig. 13 (curve a). They represent the function

$$D = f\left(\log \frac{Jt}{J_0 t_0}\right).$$

If the time of exposure is maintained constant $t = t_0$ (i.e. only the intensity J is varied), and if the intensity is regarded as a dimensionless quantity with $J_0 = 1$, then this function is simplified to:

$$D = f(\log J). \tag{1}$$

A characteristic curve of this type can be obtained by photometering the photograph of a sensitometric wedge. However, it is often more simple to use the following method in which a photometer can be dispensed with and the characteristic curve is obtained directly by a purely photographic method.

A sensitometric wedge (not a step-wedge) which possesses a logarithmic scale of intensities is copied on to the experimental photographic plate. The same wedge is placed once again on the finished print, but this time turned through an angle of 90° so that the decrease in intensity in the wedge now runs diagonally to the decrease in density of the plate. This copy is photographed together with the wedge, and equidensities are produced from the resulting photograph. Each such equidensity represents directly the characteristic curve of the experimental photographic plate.

In order to prove this, let us imagine a right-angled xy system of co-ordinates on the experimental plate, such that during the copying process the intensity of the light which has passed through the grey wedge and is incident on the plate is as follows:

$$\log J = x + a$$

(a, b, c, d, e are constants). By reason of (1) the density relations D in this copy take the form:

$$D = f(x + a). \tag{2}$$

The intensity J' of the light which has passed through this copy is then

$$-\log J' = D + b,$$

from which, by reason of (2), it follows that

$$\log J' = f(x + a) - b. \tag{3}$$

If the same sensitometric wedge is placed once more on this copy, but turned through 90°, then the light which has passed through it and is incident on the copy will have an intensity of J'':

$$\log J'' = y + c; \tag{4}$$

57

thus the light which has passed through the grey wedge and the copy will have an intensity of J''':

$$\log I''' = \log I' + \log I''. \tag{5}$$

Eqidensities are obtained from the photograph produced by this light. These equidensities represent curves of constant density on that photograph, and thus also represent curves of constant J'''

$$\log J''' = d. \tag{6}$$

(6) is the equation of an equidensity of this kind. If one imagines (3) and (4) to be included in (5), and this is then inserted in (6), the result is:

$$-f(x + a) - b + y + c = d.$$

that is to say with

$$-b + c - d = e,$$

$$y + e = f(x + a).$$

After the system of co-ordinates has been shifted in parallel this equidensity equation reads as follows:

$$y = f(x).$$

This is, however, the form (1) and it thus corresponds to the equation of the characteristic curve. If, instead of using the same grey wedge different ones are used in the x and y directions, the ordinates scale can be extended or spread out uniformly in relation to the abscissa scale.

Figure 46 shows part of a characteristic curve of this type which was obtained by the method described and which covers 3/4 of a power of ten of J in the lower region of the curve.

Fig. 46. Part of a characteristic curve obtained by means of the equidensitographic method.

When a calibrated grey wedge is used, the scale of the curve in question is also known. The value $D = 0$ can also easily be ascertained. If, in addition, the absolute value of the intensity during the exposure is known, this also establishes the distance of the characteristic curve from the D-axis.

In the present case a solution was arrived at by changing a one-dimensional problem into a two-dimensional one. There are plenty of problems which do not require to be handled in this manner, e.g., those arising in illumination engineering in which attempts are made to obtain an isophotal system for defining the characteristics of a lamp. These isophotes can undoubtedly be largely ascertained by means of equidensities, and the same is also true of the illumination of the field of vision of optical instruments.

6.2.2 SENSITOMETRY. Equidensitometry was first used by *Lau* (1959) for making sensitometric measurements. He studied the interesting photographic effects obtained with double exposures. Like the studies in section 5.1, the experiments were carried out with crossed interference fringes, that is to say, two images were exposed in succession on to the photographic material. Calculations were made of the equidensities which could be expected, and the results were compared with those actually obtained. In order to demonstrate the photographic effects which occur with double exposure, the fringes must be as contrasty as possible. Therefore the *Michelson* interferometer which is usually employed for producing interference fringes was discarded

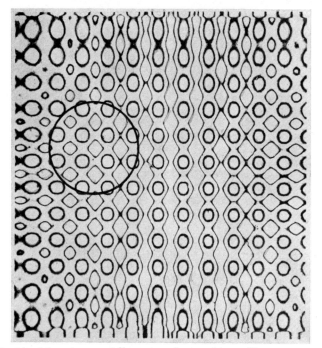

Fig. 47. Equidensities of crossed *Young* interference fringes (first exposure vertical).

in favour of a *Young* interference arrangement, in order to eliminate the decreases in contrast and the irregularities in the fringes which inevitably occur when glass optics are used. The more contrasty the interference patterns obtained, the more distinctly do departures from the first expected shapes of the equidensities become evident. In Fig. 47, firstly the first exposure appears to be more intense than the second one, and secondly, there are distinct asymmetries in the neighbourhood of the maximum and minimum intensities: the latter phenomenon is particularly marked at the place indicated by the circle.

The former phenomenon apparently arises because a first, heavy exposure produces a large number of sub-nuclei which are rendered additionally active by the second, weak exposure. This can also be confirmed by a simple test. If a bright slit is exposed twice in mutually perpendicular directions on to a photographic plate giving the same time of exposure, then the maximum density value will lie at the place of intersection. If such photographs are studied by the density-relief method the equidensities obtained are in the form of interference fringes like those in Fig. 48. It can be seen that equal densities lie at unequal distances from the maximum. The same

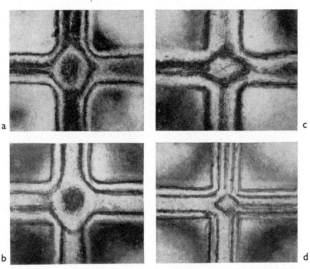

Fig. 48. Density-relief equidensities of the places of intersection of double-exposed slits.
a, b first exposure vertical. *c, d* first exposure horizontal.

result is obtained, namely the flatter falling off in density from the maximum towards the band which was first exposed, irrespectively of whether the vertical fringe (*a* and *b*) or the horizontal fringe (*c* and *d*) was exposed first. The weak places produced by the second exposure are more effective than those produced by the first exposure.

The second phenomenon can be explained by means of the well known *Schwarzschild* effect. Both the crossed interference phenomena possess maxima and minima. If, at one place, one of the interference phenomena has a minimum, then in this position the effect of the exposure is brought about in one step, but in other places where

both the intensities are effective, it is brought about in two steps. Thus the same total intensity Jt can be brought to bear at one point all at once, and at another point say by $J/2.2t$. With longer exposures lower densities are obtained as the result of the *Schwarzschild* effect, and therefore the equidensities must draw nearer to the chief maximum, whereas in the vicinity of the minimum they exhibit a greater degree of curvature.

Kröber and *Gerth* (1964) have made an extensive study of the application of the sensitometry of double exposures to film dissolves. *Gerth* (1965) has carried out a thorough investigation of the complex subject of sensitometry with the aid of equidensities and has confirmed the findings of *Lau*.

6.2.3 THE PRODUCTION OF ISOPHOTES, AND LUMINANCE DISTRIBUTIONS. The photograph of a cone illuminated from the side (Fig. 1) in which the curves of equal density are straight lines, is given as an example to illustrate that the eye is incapable of perceiving a line of equal density in an image. However, due to the influence of contrast phenomena, these equal density curves appear to the eye to be bent. On this occasion it seems useful to repeat the equidensity image corresponding to the photograph of this cone (Fig. 49a). The increase in the width of the equidensities from the centre to the edge of the picture can be explained by the path of the gradient, and shows the necessity of using a second order equidensity (Fig. 49b cf. also *Callender* 1961).

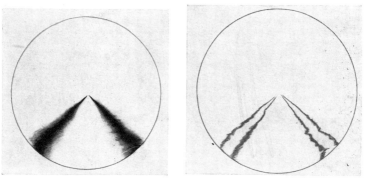

(a) First order (b) Second order

Fig. 49. Equidensities of the photograph of the cone in Fig. 1.

From the equal density curves in the image, i.e. the equidensities, it is possible to derive the curves of equal luminance in the object, namely the isophotes. Here the influence of errors caused by image transfer have to be taken into consideration.

A thorough investigation of the production of isophotes by means of equidensitometry was made by *N. Richter* and *W. Högner* (1963, 1964) during studies of extragalactic objects. A fairly large number of equidensity plates up to the 3rd order was first prepared from a photograph of the well-known Andromeda nebula. Measured values of brightness could be taken from earlier photometric studies of the same object and used to calibrate the equidensity plates. This material could be used to

61

draw isophote maps of the Andromeda nebula and to carry out important morphological researches. With the previous laborious method of point-by-point photometering there had to be a large degree of homogenization with consequent loss of many of the details.

Having developed a purely methodical photographic equidensitometric method of obtaining isophotes, the same authors (*W. Högner* and *N. Richter*, 1964) isophotometered the Andromeda nebula and its two satellites in 5 colour regions. An example is given in Fig. 50 of equidensities of the third order in the red system

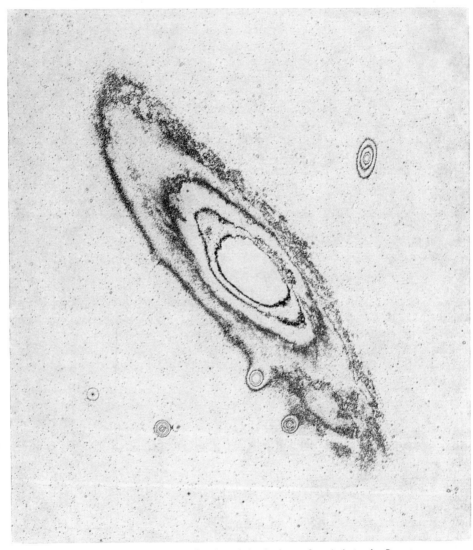

Fig. 50. Equidensities of the 3rd order of the Andromeda nebula in the R-system.

(λ_{eff} = 638 nm) and in Fig. 51 of the isophote diagram derived from it. The individual colour regions ranging from U.V. to I.R. show very different conditions and allow many conclusions to be drawn regarding the structure and physical conditions of the object.

Similar morphological and photometric methods can also be used for studying other heavenly bodies, e.g. comets, as illustrated in Figs. 52 and 53 (*Richter* and *Högner*, 1964). The isophotometry of the planet Jupiter has been carried out by *Sudbury* (1965). An isophote presentation of the solar corona has been published by *Löchel* and *Högner* (1965) and by *Högner* and *Richter* (1965).

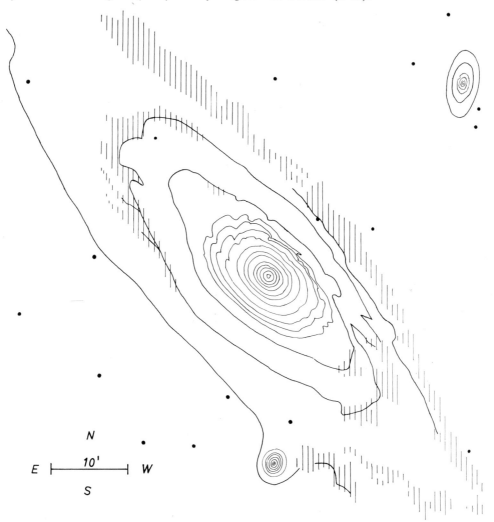

Fig. 51. Isophote diagram of the Andromeda nebula in the R-system: $\lambda_{eff} \simeq 638$ nm
(The hatching denotes the widths of the isophotes).

The photometry of large areas (cf. section 3.2) is also eminently suitable for obtaining luminosity distributions and isophotes. Whilst dioptrical-photographic equidensities can be calibrated by means of a photometric cross-section and thus made into an isophote image, when large areas are photometred the calibration must be carried out with a grey wedge which yields the legends for the image. *Lau* and *Hess* (1960, 1962) have photometered the photograph of the Orion nebula in this manner. The effect of, and the high sensitivity of this method can readily be seen from Fig. 54: even the faintest nebula hazes show a clearly diversified pattern against a black night sky.

The method can be applied to many problems in illumination engineering, astonomy, optics of the atmosphere, microscopy, etc. (cf. e.g. *Vansek* 1964, *Breido* and *Chebaterova* 1965, *Koellbloed* 1965, *Bromnikova* 1965, *Schnur* and *Feldmann* 1965, *Hodge* 1966, *Kadla* 1966).

6.3 *Spectral analysis*

6.3.1 SPECTROPHOTOMETRY BY MEANS OF DIOPTRICAL-PHOTOGRAPHIC EQUIDENSITIES. The foregoing discussions raised the question as to whether photometry by means of dioptrical-photographic equidensities could be used in quantitative spectral analysis (*Lau*, 1953). A certain amount of preliminary preparation is however necessary for this. Generally speaking, two-dimensional analysis of the densities is not necessary in spectroscopy, but only one recorded curve in a single direction is required. If one wishes to use the equidensity method for spectrophotometric purposes, the intensities of a line must first be converted into a two-dimensional image. For this one has to rely on older methods e.g., in such a way that the spectrum is extended in the direction of the length of the slit in an enlarger by means of a cylindrical lens, after which a grey wedge is placed on the image (*Kramer*, 1951). Equidensities can be drawn through these images, and this results in curves (e.g. Fig. 56a) which, for many purposes perform the same function as a recording curve. Figure 56b contains

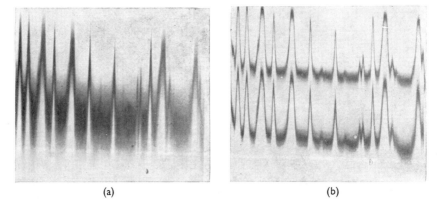

| (a) | (b) |

Fig. 56. The conversion of the intensities of spectral lines into a two-dimensional image, (a) 1st order equidensities. (b) 2nd order equidensities.

equidensities of the 2nd order which are very similar to ordinary recorded curves but which, simply by means of the logarithmically decreasing grey wedge, give a quantitative survey.

As shown in section 6.2.1, characteristic curves can be obtained on the same plate at the same time by means of equidensitometry, thus enabling a quantitative evaluation of this nature to be made. In order to test similar methods in spectrophotometry, *G. Schulz* has conducted experiments on spectral lines, the results of which will be communicated in the following paragraphs. Particular care was exercised in carrying out these studies as it was desired at the same time to obtain some critical views on the general use of the equidensity method.

A plate *A* ("Spectral blau rapid") was exposed in a Qu 24 spectrograph to the spectrum of an ultra-high-pressure mercury vapour lamp (HBO 200) in the region of approximately 335 to 390 nm. Before development, a grey wedge was printed on to the same plate using a colour filter to compensate errors symmetrically on both sides of the spectrum. The result is shown in Fig. 57a (the numbers on the scale are stated in $\mu m/100$). In addition to this a grey wedge *B* was made by projecting the image of the edge of a ruler, using an extended light source, on to a photographic plate. The construction of the light source was such that it produced an approximately logarithmic range of intensities on the plate. A contact copy of this plate was made on hard material in order to obtain the necessary gradient. This copy is the grey wedge *B* which is used further on and which, in this instance, was placed across the plate *A*. Here it was also necessary to make a separate preliminary study of the slit image with equidensities in order to select a region of constant intensity in the slit. It is expedient to make a control test of this nature in order to identify particles of dust which may have entered the slit and which, in contrast to measurements made in a rapid photometer, greatly falsify the results. Such errors can be almost entirely prevented by cleaning the slit shortly beforehand with ether and a brush. The region of constant intensity in the slit then had to be brought into the approximately logarithmic part of the grey wedge, and this was done by moving *A* and *B* parallel to each other. A series of contact prints was made of *A* + *B* together, giving various exposures, and one of these, copy *C*, the equidensities of which all fell within the region of constant intensity in the slit, was used again. Recopying the contact copy *C* on to hard material gave plate *D*, an enlarged photograph of which was made on plate *E* in a standard enlarger, *E* being placed on the slant in order to produce a one-dimensional distortion which appeared to be necessary in order ultimately to bring the height and length of the curve into an acceptable relationship with each other. Equidensities were produced from *E* on plate *F*. The enlargement of *F* is shown in Fig. 57b.

A set of control experiments was then set up, starting with plate *C* which was enlarged at once in the special enlarger (with constant illumination), designed by *F. Hodam*. This gave plate *D'* from which equidensities were obtained on plate *E'*.

The following sources of error in spectral analysis using dioptrical-photographic equidensities should be mentioned. Statistical fluctuations in density have a more harmful effect on the results in the case of equidensities than in photometry with a slit, because equidensities yield "point scanning", whereas a photometer gives aver-

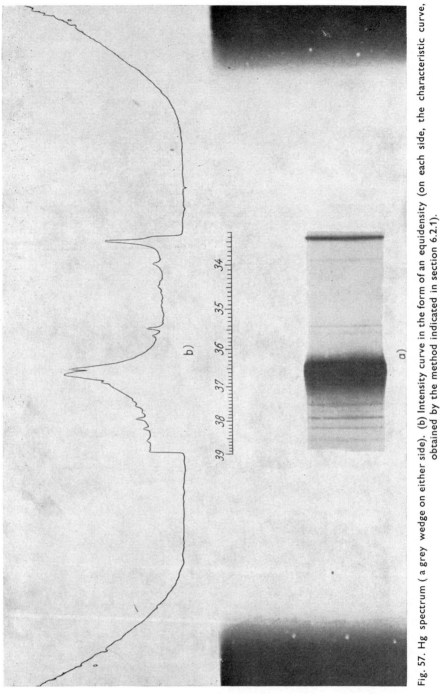

Fig. 57. Hg spectrum (a grey wedge on either side). (b) Intensity curve in the form of an equidensity (on each side, the characteristic curve, obtained by the method indicated in section 6.2.1).

ages via a long slit. Since this source of error is inherent in the principle of the method, it can never be eliminated, although possibly it can be kept within reasonable bounds by restricting the number of copies to a minimum or by enlarging at once.

Scattered-light effects (halation) and images which, when copied or enlarged are not reproduced exactly in the form of points, can cause an equidensity to flatten, and render the position of the equidensities dependent on the density gradients, and thus bring about an unsystematic "clogging up" of the sharp peaks.

Mention must also be made of the systematic falsification of the densities due to slight variations in the constancy of the illumination of the slit and to the presence of small particles of dust in the latter. These errors can possibly be avoided by interposing cylindrical lenses.

The requisite apparatus for the perfect and efficient execution of the entire process is considerable. For example, enlargements which are free from image defects and variations in intensity are necessary. The latter can, however, be compensated by using an *intensity filter* which has to be produced experimentally: the free illuminated field of view is allowed to act on a photographic plate which can then be used directly as a filter in front of the recording plates. It is, however, always absolutely necessary to place the plate in exactly the same position and to adjust the lamp, condenser, etc. in invariably the same way: only under these conditions is the filter able to function correctly.

The results of tests made to use *two-dimensional* equidensitometry in spectrophotometry are not very satisfactory, mainly because in this case we are confronted with a typical *one-dimensional* photometric problem. The transformation into two dimensions is beset with the difficulties which have already been described in detail. Moreover, spectrophotometry presents particularly difficult problems because, in the case of spectral lines we are dealing with intensities of extremely steep gradation.

6.3.2 SPECTROPHOTOMETRY BY MEANS OF THE DENSITY-RELIEF METHOD. Since spectrophotometry requires one-dimensional photometry in one direction, the density-relief method in the oblique contour section is therefore suitable (section 3.3) Fig. 58a shows an enlarged section of a spectrogram (apparatus: Zeiss-Jena Qu 24). In this section the photographic layer of the original plate was photographed with an interference microscope in such a manner that oblique contour sections at a distance of $\lambda/2$ apart (about 270 nm) were recorded by the density relief (Fig. 58b). Since it has already been shown that these interference curves can be interpreted as density relations, the density is obtained directly from each of the curves in this family of curves, and it is only necessary to calibrate, i.e., to co-ordinate the interference systems with the density values. Figure 58c shows the curve which was obtained by measuring the two central groups of lines on a rapid photometer. It is seen that every detail can be inferred directly from the interference lines. Whether this method is capable of giving the same degree of accuracy ($\pm 0.01\ D$) as the photometric method depends on various circumstances, especially on the smoothness of the gelatin layer after drying, and on the extent to which this layer actually follows the density. In individual cases it is then possible to make a further evaluation of the resulting inter-

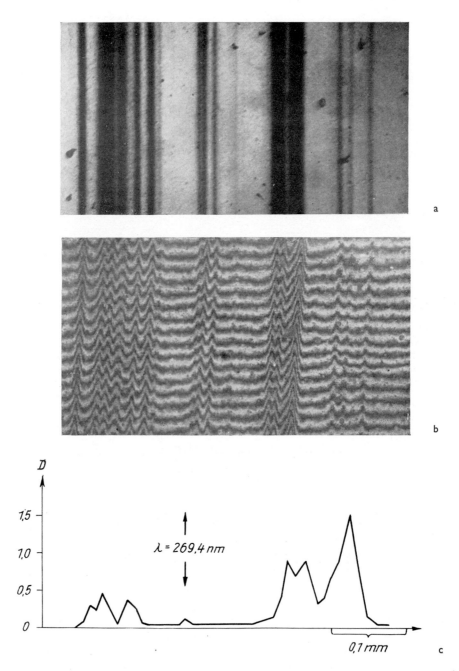

Fig. 58. Spectrophotometry by the density-relief method. (a) Section of a spectral plate (Zeiss Q 24). (b) Evaluation of the plate by means of the density-relief method. (c) Curve obtained from the measurements made on the rapid photometer.

70

ference lines with the aid of photographic equidensities (by the *Sabattier* method). These questions have been studied thoroughly by *H. Schmidt* (1959, 1960).

In any case the following advantages appear to argue in favour of photometering spectral plates by means of the density-relief method: namely the rapid survey of the intensity distribution in the spectrum, the possibility of making relative and absolute measurements, frequently with much more than sufficient accuracy, and above all, the spanning of an extremely large density range (up to a density of $D = 4$) and thus avoiding the necessity of taking the usual series of photographs with different times of exposure.

H. Schmidt and *J. Engelbrecht* (1958) have given a detailed description of a simple interference arrangement for the density-relief method. This device was then used in fundamental work on the photographic photometry of stellar spectra (1960) using both the "layer lines method" (interference contrast) and the "profile section method" (oblique section). An example of the former method is the interference contrast image of a thread-like infra-red spectrum of short dispersion shown in Fig. 59, and of the latter method, the interferometer record of part of the solar spectrum (Fig. 60). In the detailed discussion of the results a comparison is made with the photometric methods used for transparencies, whereby the great merit of the density-relief method in its ability to span *an extremely large range of exposures* is revealed. At the same time, the resolution of fine detail far beyond the upper limit of the photometric density range of the transparency is maintained.

6.3.3 THE STRUCTURE OF SPECTRAL LINES. Photographs of the solar spectrum taken by means of a high-intensity diffraction grating reveal structures of the *Frauenhofer* lines which are due to variations in wavelength. Exact measurement of these fluctuations

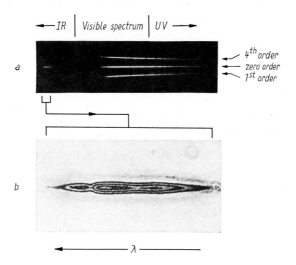

Fig. 59. (a) Thread-shaped spectrum of a star with the I.R. part in the zero order. (b) Interference-contrast image of the I.R. spectrum of (a), greatly enlarged.

71

allows the depth relation of the granular *Doppler* displacements to be determined. Here it should be possible to obtain a figure showing the density relations for all points in the slit by recording the spectra with the aid of a photometer. However, for various reasons, this procedure is difficult and time consuming.

Lines of comparison

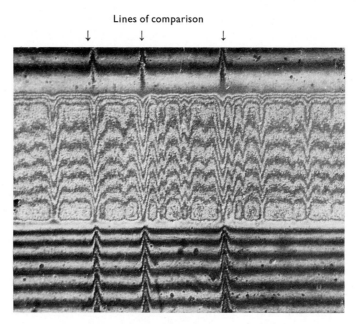

Fig. 60. Interferometric record of part of the solar spectrum.

E. H. Schröter (1958) has applied the *Sabattier* equidensity method to his spectrograms and thus, by a simple means, obtained accurate results of the line structure. He used, for example, the chromospheric structures in the nucleus of H_α as well as the two Cr-lines $\lambda = 4339\cdot46$ and $\lambda = 4339\cdot72$ in the violet region of H_y (see Fig. 61). The equidensities (3rd order) of the two metal lines (Fig. 62) can be used to deduce directly variations in contour of the lines, the elementary structure (in the nucleus of the line on the right) as well as the variations in wavelength; and from this the granular velocities can be derived with an accuracy of $\pm0\cdot01$ km/s. The numerous astrophysical aspects which can be pursued with these studies are beyond the scope of this book.

6.4 *The evaluation of interferograms*

6.4.1 TWO-BEAM INTERFERENCE FRINGES. The use of the equidensity method for testing surfaces arises particularly in the evaluation of interferograms of surfaces. This has already been made clear in the few examples accompanying the explanation of the principles of the method (in section 3.1.1 in particular). As mentioned at the outset, in section 1, the development of equidensitometry was actually prompted by the basic problem of improving the evaluation of two-beam interference fringes.

Ever since interference microscopy found its way into methods of research in science and technology, tests have been made of the surface roughness of the most highly finished surfaces (glass or metal) by means of an interference microscope. Interference microscopes are combinations of an optical microscope and an interfero-

Fig. 61. The Cr-lines in the violet region of H_γ (part of the solar spectrum obtained with a high-intensity diffraction grating, 1 Å ≙ 16·9 mm).

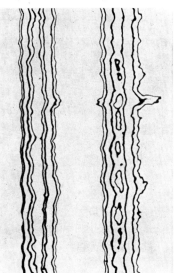

Fig. 62. 3rd order equidensities of the Cr-lines made from Fig. 61 (enlargement, 1 Å ≙ 83·0 mm).

meter. Both instruments are either connected optically in series, or are inserted into one another. Figure 63 serves to illustrate the first arrangement (*Krug* and *Lau* 1951).

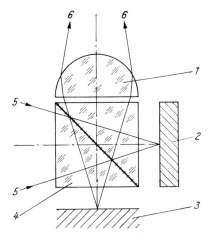

Fig. 63. Incident-light interference microscope with a *Michelson* interferometer in front of the objective (*Krug* and *Lau* 1951).

It represents diagrammatically a simple reflection interference microscope. The microscope objective *1* and the object *3* are separated by cube *4*, the semitransparent diagonal surface of which splits up the light coming from *5* into two so-called coherent beams. One of these beams strikes the object *3* from which it is reflected, and it then proceeds in direction *6* to the eye-piece of the microscope. The other beam strikes a flat comparison surface *2*, and on passing through the separating surface, likewise reaches the eye-piece. On looking into the latter the surfaces *2* and *3* are seen simultaneously, and on joining these two images together, interference phenomena which are superimposed on the image of the object make their appearance. If object *3* exhibits no irregularities when compared with the smooth comparison surface *2*, then the field of view appears equally bright since both the interfering beams meet in the same phase and reinforce each other (two-beam interference fringes). The arrangement thus behaves like a small *Michelson* interferometer, the surfaces of which are observed in a microscope, and one of which is formed by a test surface. The microscope magnifies the details on the surface and renders them visible. However, in all places where there are depressions or elevations, the optical paths become longer or shorter than the wave trains coming from the comparison surface. If the differences in path are half a wavelength or an uneven multiple thereof, the wave trains in the interfering beam are extinguished in pairs, and the corresponding parts of the image appear dark. Since all the parts of the image on the same horizontal level produce the same interference phenomena, light and dark interference lines appear in the microscope. Figure 64a illustrates the interference image of a glass bubble, a so-called interference-contrast image or image in horizontal section. If the comparison surface or the object is tilted slightly towards the optical axis of the interferometer, line images of the elevations in the layer are seen in the field of the microscope (64b, c, d) and a simple interference image or image in oblique section is also indicated (see also Fig. 27).

Since the interference lines link up places of equal level on a surface, the testing of surfaces with an interference microscope can easily be understood. The larger the degree of magnification given by the microscope, the finer are the details which can be discerned on the surface: since all the details contribute to the production of the interference phenomenon, they are revealed by the variations in the deflections of the interference fringes, and the measurement of differences in contour is then a very simple process. The accuracy of the measurements is the same with all interference microscopes, since the phenomenon of interference is independent of the lateral resolving power of a microscope. The set-up indicated in Fig. 63 is of course only suitable for use at fairly small apertures: it gives only a limited lateral resolution, but has the advantage of being simply constructed (an attachment for standard microscopes). During recent decades many optical arrangements have been devised for greatly increasing the efficiency of interference microscopes, and many refinements have been introduced into the methods of measurement with these instruments (*W. Krug*, *J. Rienitz* and *G. Schulz*, 1964, *A. Cosslett*, 1965).

The accuracy attainable in measuring profiles or differences in contour respectively of average roughness, etc. depends first and foremost on the original photo-

74

graph which should therefore be as contrasty as possible in order to make sure of localizing the maximum to exactly 1/10 of the distance between the fringes, i.e., $\lambda/20$. Measures for achieving sufficient contrast by the use of suitable apparatus have been specified by *Räntsch* (1952) and will not be described here. The requisite increase in contrast can be achieved by re-copying on to hard photographic material, and in this

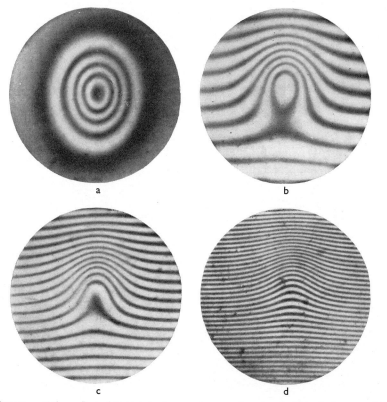

Fig. 64. Variation of the reflected-light interference images of a glass bubble during transition from horizontal (a) to oblique sections (b, c, d).

way an accuracy of $\lambda/60$ is usually obtained. Equidensitometry thus enables the accuracy of these measurements to be increased, since, like the interference fringes from which they are obtained, equidensities can be regarded as contour lines. Normally the increase in accuracy which is achieved from one equidensity order to the next is about half an order of magnitude before the limit of photographic resolving power is reached. The maximum in curve A (Fig. 65), which is intended to represent the intensity relations of a two-beam interference fringe is fixed at $\pm\lambda/20$. An equi-density A_1 of the 1st order which is localized at $\pm\lambda/100$ is then obtained. The second order, A_2, which yields four curves for one fringe is then already fixed at about $\lambda/500$ and corresponds in profile to a difference in contour of about 10 Å. These are of course only guides in the matter. It follows from section 3.1.3 that choice of the right

75

type of plate (γ-value) provides a means of obtaining equidensities of any required slope. In our example the equidensity A'_1 at $\pm\lambda/200$ could be obtained directly as the first order. However, the question arises as to whether it would not be better to

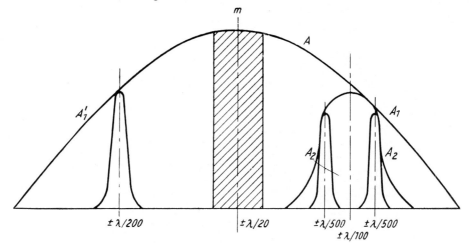

Fig. 65. The accuracy of measurement with interferograms.

obtain four curves (A_2) instead of two (A_1) to describe the field, since according to earlier explanations (see 3.1.3) it is preferable to make the A_1 equidensities wider from the outset. If a sharp A'_1 equidensity is to be obtained it is expedient to begin with

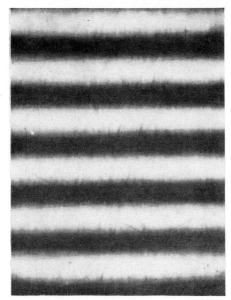

Fig. 66. Interference photomicrograph of a gauge block of poor quality.

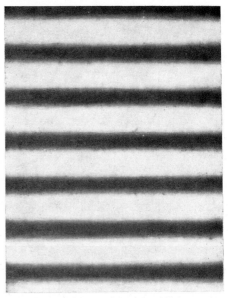

Fig. 67. Interference photomicrograph of a surface of a gauge block of very good quality.

76

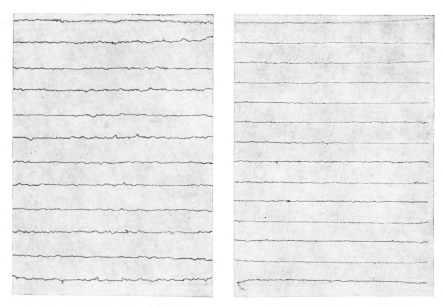

Fig. 68. Equidensities of Fig. 66. Fig. 69. Equidensities of Fig. 67.

hard, re-copied plates with which an accuracy of $\pm\lambda/60$ in the measurements can easily be achieved. The A'_1 equidensities of the first order will then give an accuracy of $\pm\lambda/200$ in the measurements. These astonishingly high degrees of accuracy are due to the fact that the equidensities lie principally on the sides of the intensity distribution of the interference patterns, where, owing to the high intensity gradients, the positions of the curves are particularly sensitive.

We shall illustrate this by means of a practical example. Figures 66 and 67 show interference micrographs of two gauge blocks of different manufacture, and it can indeed easily be seen that the surface shown in Fig. 67 is less rough than that in Fig. 66. It is, however, quite impossible to evaluate the two figures quantitatively, because the roughness of the two gauge blocks obviously lies far below $0.03\,\mu\text{m}$. The corresponding equidensity images (Figs. 68 and 69) on the other hand are capable of being measured unequivocally, and give an average roughness of about 50 Å for the better gauge block and of about 100 Å for the one of inferior quality.

These figures show, for example, that each individual stage in the polishing of high-grade surfaces can be controlled, the most important feature of this method being that it gives quantitative values which are not so easily obtainable by other methods. Moreover, it is remarkable that, as already mentioned previously, the surface is described by a larger number of curves than in the case of an ordinary two- or multiple-beam interferogram. In the case of multiple-beam interference patterns which give accuracies in measurement of the same order of magnitude, the information content is very largely dependent on the shape of the surface, and especially with curved surfaces it is very problematical, as will be shown in section 6.4.2.

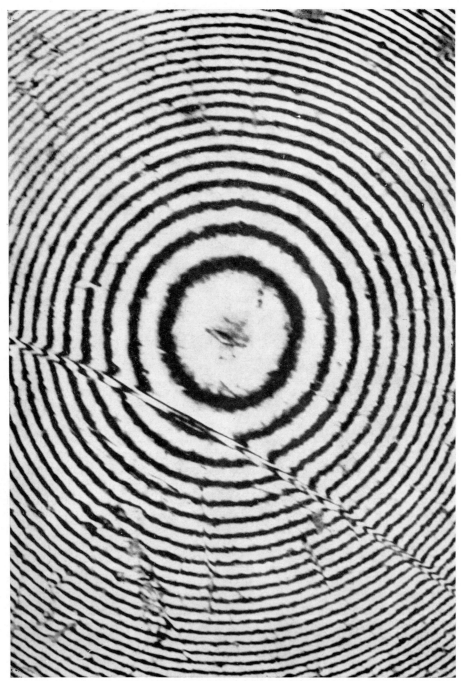

Fig. 70. Interferogram of the surface of a polished steel ball.

Fig. 71. Equidensities of Fig. 70.

Figures 70 and 71 give examples of the use of the method for testing curved surfaces, and these show clearly that it is also possible to test the *shapes of surfaces* in the micro-region.

6.4.2 MULTIPLE-BEAM INTERFERENCE FRINGES. The difference between two-beam and multiple-beam interference fringes can be made clear by means of a simple diagram. In Fig. 72a, let *O* be the object and *C* the comparison surface. The interference phenomenon which owes its existence to the difference in path of the two rays which are reflected from the object and the semi-transparent surface respectively, can be derived unequivocally by geometry. Every point in the object is compared with the comparison surface, irrespective of the angle of incidence of the light and of the angle and thickness of the wedge in operation. The influence of the shape of the surface or of the aperture can be perceived comparatively easily. The multiple-beam interference fringes which only occur with very strongly metallized surfaces and with comparison surfaces which have been coated up to 95% with metal, are brought about by the combined action of many part-beams (Fig. 72b). The summation, in terms of intensity, leads to the known narrow interference fringes, the width of which depends on the degree of metallization. The intensity distributions of such interference fringes are shown in Fig. 73. It is obvious that the narrow fringes, *2, 3*, are better localized than the broad ones, *1*, and therefore that the accuracy of measurement with multiple-beam interference fringes must be greater than with two-beam interference fringes. For technical details of conducting the test the reader is referred to the literature (*Tolansky*, 1948, 1955, 1960).

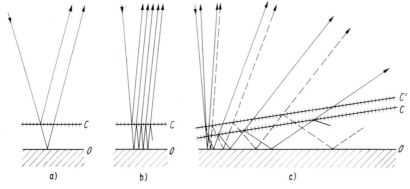

Fig. 72. Diagram showing the formation of two-beam and multiple-beam interference.

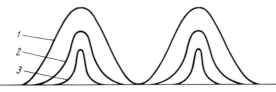

Fig. 73. Diagram showing the intensity distribution with two-beam and multiple-beam interference.

80

It has already been mentioned in section II that in applying the equidensity method to two-beam interferograms about the same degree of accuracy is achieved as that which otherwise is only possible in special cases with multiple-beam interference fringes. This was demonstrated in the previous section when dealing with the problems involved in testing the surfaces of highly polished manufactured materials. If one wonders whether it is still expedient to apply the method to multiple-beam interference fringes, then the following point must be taken into consideration: the sharpness of an interference fringe, i.e., the slope of the intensity curve in an oblique direction to the fringe depends on the degree of metallization of the surface, i.e., of the test and control surfaces. One is not, however, always dealing with extremely highly metallized surfaces, and thus the fringes are not particularly narrow, this being the case with most industrial multiple-beam interference microscopes. Equidensity images can then be produced directly from the interferograms and the accuracy of the measurements increased just as in the case of double-beam interferograms (*Lau*, 1953). It is quite a different matter with most of the multiple-beam interference images with sharp lines of 0·01 to 0·02 mm. in thickness published by *Tolansky* (1948), *Rasmussen* (1945) et al. The sides of these lines occur in regions which are practically beyond the scope of the equidensity method, for the same reasons as those which hold for equidensities of higher order (section 3.1.4).

If multiple-beam interference fringes are to be used for testing the roughness of surfaces it is advisable from the outset not to aim at obtaining too sharp lines, so that the latter can then still be evaluated by means of equidensities. This gives the advantage of being able to obtain several adjacent lines from one order and to cover the test-object more closely with interference lines.

This method can also be recommended for other more weighty reasons. The two metallized surfaces, the test and control surfaces, together form a wedge which causes the interference fringes to appear. The higher the degree of metallization of the two surfaces, the larger will be the number of single beams involved in producing the interference phenomenon. The larger the angle δ and the thickness d of the wedge, the larger will be the region on the surface which is decisive for a particular point in the interference phenomenon, since the part-beams involved depart sideways and are reflected from various points on the surface. Smudging of the topographical details on the surface is unavoidable, and this is the more noticeable, the larger the number of part-beams taking part (degree of metallization) and the larger the region on the surface from which these part-beams are reflected. This region is, of course, also dependent on the resolving power, i.e., on the aperture of the lens system employed.

According to *Krug's* investigations (1955) which stem from the previous considerations, the information content of surface interferograms obtained by the multiple-beam method decreases with increase in the degree of metallization and with increase in the angle and thickness of the wedge in the interference arrangement, and also with increase in the degree of magnification produced by the lens-system employed. In an extreme case, details may disappear completely, and then even when the surface is actually rough, the interference fringes are completely smooth and simulate those of a surface as smooth as a mirror.

An interference image (Fig. 74) which was published by *Perthen* (1954) is suitable for studying these differences. Here we have the original print of a workshop photograph which has been kindly placed at our disposal by the firm of *Johansson*. According to the data supplied by this firm the photograph was taken with a multiple-beam interferometer at a magnification of 75 times, only half the interference plate having been coated with metal. Two-beam interference fringes are formed on one half of the photograph of the sphere, whilst on the other half multiple-beam interference fringes are formed through the matallized half of the plate. The spherical surface was not

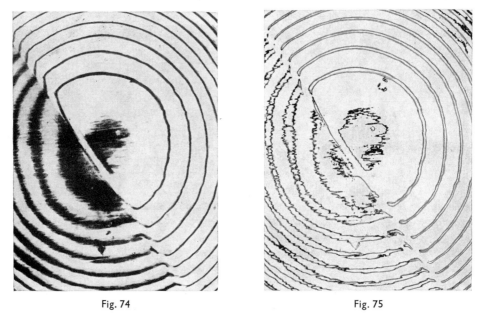

Fig. 74 Fig. 75

The interference image of a spherical surface with two- and multiple-beam interference fringes toge ther (Fig. 74) and the equidensities of this photograph (Fig. 75)

coated with metal. The photograph was produced in order to demonstrate how much narrower and therefore more easily measurable the multiple-beam interference fringes are in comparison with the blurred two-beam interference fringes. Here, however, it is more expedient to ask about the information content of the two photographs. Since, statistically, the roughness is presumably distributed evenly over the surface of the sphere, there would, on an average, have to be an equal amount of deflection in the details shown in both parts of the photograph, but apparently this is not the case. Whereas the two-beam interference fringes, e.g., in the direction of the polish marks, exhibit about the same degree of irregularity over the entire surface, these irregularities diminish rapidly in passing away from the central spot in the case of the multiple-beam interference fringes. According to the previous statements, no other result can really be expected, but an attempt will however be made to arrive at absolute values of measurement. In such cases equidensities have proved very valuable for making such

evaluations. If the equidensity method is applied to Fig. 74, Fig. 75 is obtained. Here it is immediately evident that even in the multiple-beam part of the photograph more details can be recognized than before. In the two-beam part, the measurement gives an average surface roughness of $\lambda/10$ no matter which equidensities were used in making the measurement. In the multiple-beam interference region about the same surface roughness of $\lambda/10$ only occurs in the central spot. This however, appears to decrease very rapidly in the direction of the grooves, and in the region of the first two orders it still only reaches $\lambda/50$. In a direction perpendicular to the polishing grooves the equidensities are, on the whole, perfectly smooth, and the apparent roughnesses can be stated as being $\lambda/200$ or less. It is absolutely clear that the results of the two halves of the photographs cannot be combined: only one of the two results can be the correct one, and the views originally expressed on the experimental facts show that the multiple-beam interference fringes obtained with spherical surfaces of this kind can lead to deceptive values. The values obtained for the roughness of the surface will be too low. Thus the sharpening of the bands brings about no improvement in the evaluation unless, at the same time, attention is paid to a few very important points in the technique of the multiple-beam method, which moreover, according to *Tolansky* (1948), *Edenholm* and *Ingelstam* (1954) were stated at the time, but passed almost unheeded. This is also shown for instance in photographs of smooth surfaces (*Krug*, 1955, 1956).

On the basis of the examples and discussions given here, multiple-beam interference fringes can only be used under very definite conditions which have to be strictly adhered to when testing surfaces. All the quantities which arise in interferometers, such as the angle and thickness of the wedge, the degree of reflection and the aperture employed, impair the conditions and counteract the aim of obtaining exact surface irregularities, and indeed they are all proportional in the same direction. The commonly discussed multiple-beam interferograms are an alluring proposition because of the fineness of their lines, but in most cases they are of no metrological value at all, whereas two-beam interference fringes yield more reliable results with equidensities.

6.4.3 SPECIAL INTERFEROGRAMS. Not only can equidensities be used successfully for increasing the accuracy of measurement of interference fringes when measuring roughness and thickness and testing the shape of an object, but they can also be used for instance for determining refractive indices. The determination of the refractive indices of thin, non-plane-parallel crystalline objects under an interference microscope is dependent on the following factors. Since a system of interference fringes always yields only the phase, i.e., a combination of the two unknowns, *thickness* and *refractive index*, according to G. *Schulz* (1954) two different systems of fringes are used, the difference in the paths of which depends in different ways on thickness and refractive index: one of the systems consists of *Mach-Zehnder* interference fringes† whereas the other consists of interference patterns in the

† In the transmitted light arrangement of the interference microscope according to *Krug* and *Lau* (1951), instead of a small *Michelson* interferometer (p. 73) a small *Mach-Zehnder* interferometer is used under the objective. The *Mach-Zehnder* interference fringes are produced in this interferometer and their shape is influenced by the transparent crystal.

crystal.† The adjustment is made (by the superposition of a virtual wedge) so that the two systems of fringes intersect each other.

The relation between the changes in position of the arrangements of the two systems of fringes has now to be measured, and this is done by projecting the points of intersection of these two systems on to that virtual wedge which is perpendicular to the direction of the fringes, and measuring the distances between the points of intersection in the projections and bringing them into relation with the distance between the fringes of that wedge. The refractive index is then a simple function of this relation. Thus everything depends on measuring as accurately as possible the position of the said points of intersection as well as the distance and direction of the interference fringes of the wedge. This is best and most accurately accomplished by using the equidensities of the photograph in question. These points of intersection then appear to be surrounded by annular equidensities which have often coalesced to form chain-like structures. The central points in these rings represent the required points of intersection (Fig. 76).

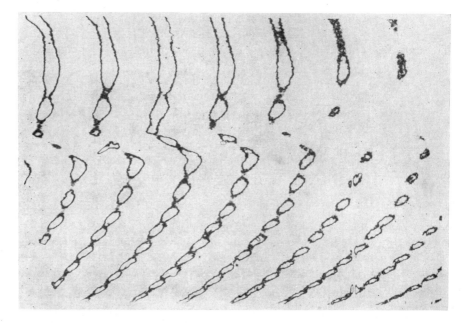

Fig. 76. Determination of the refractive index of a CdS crystal by means of an interference microscope.

Another example of the use of equidensities is the *two-sided-method* (*Schulz* 1956). This is a method which permits the thickness and three-dimensional form of thin (particularly microscopic) objects to be measured with the aid of two-beam interference fringes. The interference fringes are produced as incident-light interference

† The second system of interference fringes is produced inside the crystal by the interaction of two beams, one of which passes through the crystal, whilst the other is reflected twice.

84

fringes of equal thickness in succession on both sides of the surface of the object. This is accomplished in a somewhat modified *Michelson* arrangement, in which one of the two flat mirrors is replaced by the object, which, together with a flat *standard of zero thickness* placed directly beside it, stands approximately perpendicular to the optical axis. The zero thickness standard is produced by pressing together two partially overlapping glass plates of suitable shape. It defines a plane *P* which (during the measurements), in conjunction with the object, forms a solid complex arrangement *C*, the whole of which can be rotated in such a way that light is reflected from each of the two sides of *C* in succession.

After the thickness of an object in this set-up has been measured (a more detailed description will not be given here), an image of the entire three-dimensional form of the object can be obtained in the following way, on the basis, amongst other things, of the production of equidensities. The reference plane (image of the mirror in the object space) is adjusted parallel to P, and the interference fringes which are thus formed between the reference plane and the "front" surface of the object are photographed. *C* is then *rotated through* 180°, the reference plane is again adjusted parallel to *P* and

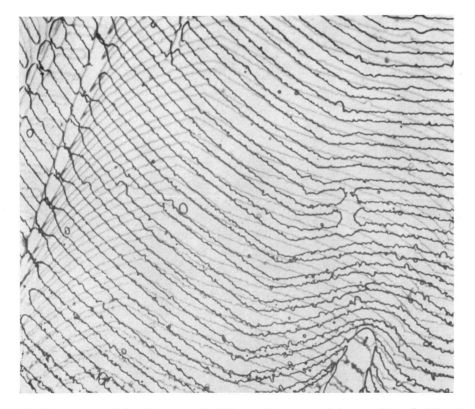

Fig. 77. Measurement of the thicknesses of a CdS crystal by means of the *two-sided method* (*Schulz*). (One of the equidensity systems has been reduced).

once more photographed. This second photograph shows the interference fringes which are formed between the reference plane and the other surface of the object. Equidensity plates are now produced from the two photographs, and these plates are placed emulsion to emulsion on top of each other in such a manner that corresponding places in the front and back of the object cover each other. At this stage fresh images are made, thus resulting in a *two-sided* photograph (Fig. 77). In the latter a certain distance of *P* corresponds to each equidensity of the front and back of the object. If this distance be imagined to be written down beside each equidensity, then the thickness can be read off at each point as the sum of the two distances. This photograph, moreover, conveys an image of the total three-dimensional shape of the object which, in this case, is a CdS crystal.

Thus, here the production of equidensities is absolutely necessary because the two-beam interference fringes are too wide to allow the two systems of interference fringes to be detected sufficiently clearly after two such plates have been superimposed.

6.5 *Image analysis*

6.5.1 GENERAL CONSIDERATIONS. A large part of all experimental and technical work culminates in the production of an image. It is usually left to the perception of the eye to detect what the image has to offer. It is, however, by no means correct to assume that the eye is capable of making an exhaustive analysis of the information content of the image without further measures having to be taken (*Lau*, 1956).

In the following an account will be given of image analysis with the aid of methods which enable the information content of an image to be grasped as completely as possible.

In general, an industrial physicist or a biologist, when producing an image, is satisfied with the result if he considers that the points in the image and object correspond with each other as closely as possible. The opinions held on the resolution of the image-forming system are also an extremely important aspect of this subject. If the distance between the details is less than half the wavelength of the light or of the electron beam employed, it is absolutely impossible to recognize the details, especially when many of those which are closest together act in conjunction. These details are concealed by diffraction phenomena, just as say a field of ruins is hidden under desert sands. In order to create images in which all the details can be detected, recourse is usually had to enlargements in which details which are just still resolved are at a distance of $\frac{1}{2}$ mm from each other. With this rule governing the still useful degree of enlargement it is, however, by no means possible for the eye to make an exhaustive analysis of the image. There are in addition other threshold values, e.g., the *nonius* threshold, which is considerably smaller. Thus it is not sufficient to keep within the bounds of this useful degree of enlargement when enlarging an image.

First of all we shall give a few facts to show that perception of an image does not exhaust the image content or may even falsify it. Of the numerous elements in an image, the eye must seek out some combination which will enable the object to be

recognized. Our system of perception functions in a similar manner to an electronic brain, say in solving problems in a game of chess, whereby certain simplifying rules are introduced, otherwise each step would produce an infinite number of methods of solution. In perception plenty of possibilities of image interpretation may thus be absent. It should be remembered that a magician, for example, by skilful manipulation can conceal from the eye processes which, in themselves, could easily be detected. In this connection we would refer once again to the photograph of the cone (Fig. 1). Here essential information is lost to the eye in that lines of equal luminance run radially in straight lines. The isophotes of the object correspond with the equidensities in the image (Fig. 49). Since the eye cannot perceive lines of equal density, in this case recourse must be had to equidensitometry in order to make an exhaustive analysis of the image content.

Similar relations may be expected, especially with all images which are obtained photographically, whether they be scientific, biological or astronomical photographs, or are produced with the aid of a camera, microscope or telescope. Even when it is not a matter of direct importance to reconstruct the photometric isophotes in the object (cf. section 6.2.3), equidensities can improve the evaluation of an image substantially: they are also of considerable assistance in emphasizing differences in the details, in making the boundaries more distinct and in disclosing the structure of the object, etc. Here it may be useful to obtain families of equidensities which describe the entire intensity distribution.

6.5.2 THE ANALYSIS OF PHOTOMICROGRAPHS. Equidensitometry has been little used in the analysis of photomicrographs, and therefore only general indications can be given here. The future prospects of the use of the equidensitometric method in various fields of morphology appear to be bright.

Banig and *Mieler* (1964) have attempted to obtain a better differentiation of chromosomes within the framework of the aberration forms (Figs. 78a, b, c, d). The photographs show distinctly that it will now be possible to make more accurate measurements of individual chromosomes.

The giant chromosome of a type of mosquito can be regarded as an example of the morphology of chromosomes. Figure 79a shows a section of a photomicrograph of this chromosome: the intensity distribution is traced in (b) and (c) by families of equidensities. In Fig. 79c eight families of equidensities have been drawn through another section of the same photograph. The families of equidensities are produced as follows. Two equidensities of the 1st order are first obtained in different density regions using the softest possible material corresponding with that in section 3.1.4. Only in this way is it possible to obtain, in the following stages, equidensities which lie at all far apart from one another. Figures 79b and 79c are equidensities of the 3rd order, i.e., four curves which, corresponding to the two different original equidensities, belong to different density regions. In Fig. 80c the two images of the 3rd order have been printed on top of each other to form a single image, thus giving eight curves. Naturally in making such an analysis, both the original and the equidensity images are always studied together. Additional information is provided by the gradient which is recog-

J. Heydenreich, H. Bethge and *U. Ruess* (1964) have also engaged in a thorough study of the objective evaluation of electron-microscope resolution test-photographs. They based their theories on *Scherzer*'s postulate, according to which two points in an object can only be regarded as being separated if the constitution of the resulting intensity distribution in the two appropriate sections of the image discs is such that the intensity I_2 in the bridge between the two image sections does not exceed 75% of the intensity I_1, which is equal to the peak intensity assumed for the two image sections. When allowance is made for the background intensity I_0, the following relation holds:

$$(I_2 - I_0)/(I_1 - I_0) = 0.75.$$

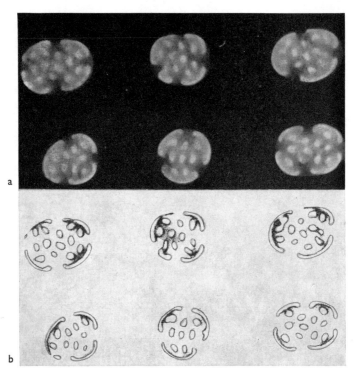

Fig. 81. The fine-structure of the diatom *a* in the equidensity image *b* (mirror image of it).

The relation between the intensities I_1 and I_2 of interest and the density values D_1 and D_2 which can be arrived at from the resolution test-photograph and which we shall define as the peak and critical densities, respectively, is given by the characteristic curves of the photographic negative and positive materials. Instead of estimating the density distribution visually, work is conducted with the defined density values D_1 and D_2. Figure 82 shows diagrammatically three density distributions which are described accurately in the paper. The regions in the photograph of the test-object which are co-ordinated with the peak density D_1 take the form of points in the ideal

90

case, whereas the curve of equal density corresponding to the critical density D_2 when the limit of resolution at which D_2 is identical with the bridge density, is covered, consists of two closed contiguous curves. The photograph on the right represents the case of well-separated points, whereas in the one on the left two object details which lie below the limit of resolution can be seen. Equidensitometry with which discrete regions of equal density can be separated from a previously given continuous or discontinuous density distribution in the form of equidensities, also covers the densities D_1 and D_2 in the photograph of a test-object. To this end we

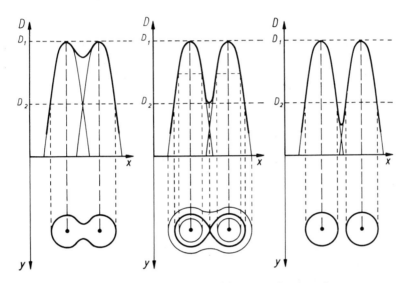

Fig. 82. Peak densities of two neighbouring points in an image.

prepare two equidensity images from the photograph of the test-object, one with the practically dot-shaped equidensities of the peak density D_1, and the other with the equidensities co-ordinated with the critical density D_2, from the shape of which the limit of resolution can be concluded.

Figure 83 gives an example of the graphical determination of the density appertaining to the critical equidensities. First of all the peak density D_{IN} and the background density D_{ON} were derived equidensitometrically from the negative, and from these values the intensities I_1 and I_0 were arrived at via the characteristic curve of the negative material. These values can then be used to calculate the bridge intensity or the critical intensity I_2 in accordance with the *Scherzer* relation. By making an equidensitometric estimation of the density value D_1 of the peak equidensities in the positive, the position of the known hypothetical characteristic curve of the positive material can be established. The density D_2 of the critical equidensities can thus be easily determined graphically. With the positive materials employed, the background density D_0 is barely recorded.

91

Figure 84 gives an example of the evaluation: (a) shows the enlargement on hard material, (b) the equidensity image of the peak densities, and (c) the equidensity image of the critical densities. The distances between the individual points in the object can best be inferred from the image of the peak equidensities. Observation of the critical equidensities reveals that the distance between three of the marked pairs of points corresponds to the resolving power, which, in this photograph, probably lies

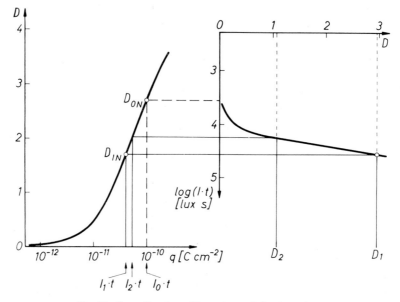

Fig. 83. Co-ordination of intensity and density values.

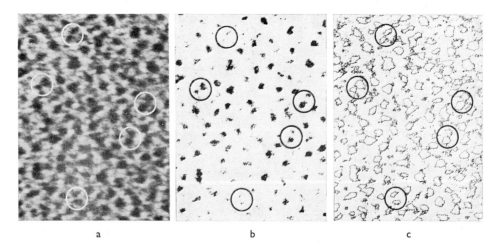

a b c

Fig. 84. Peak equidensities (b) and critical equidensities (c) of the test object (a).

at 12 Å. A pair of points can no longer be regarded as separate in the meaning of the *Scherzer* postulate, whereas another pair of points lies within the limit of resolution and thus appears well separated.

Figure 85 serves to demonstrate the influence of dirt on the object on the resolving power. The upper row is concerned with the peak equidensities and the lower row with the critical equidensities of three resolution tests of the same region in the object which have been photographed in succession. Whereas neighbouring points in the object represented by the equidensities still appear to be separated in the first photograph, this is no longer the case in the following photograph, and in the last photograph the equidensity image in the case of the critical densities only exhibits confused structures in this region. This is largely caused by dirt on the object.

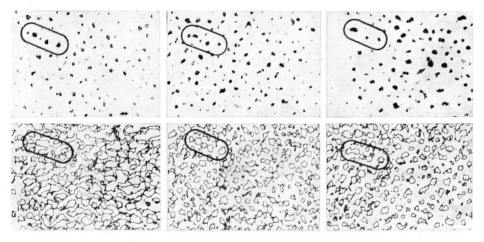

Fig. 85. Dirt on the object, and resolving power.

The improved exploitation of the information content of a resolution test-photograph afforded by the proposed equidensitometric method of evaluation, results in obtaining much more objective evidence than is possible with ordinary visual methods of estimating the photographs of test-objects. The somewhat greater expense involved in the evaluation appears justifiable in view of the advantages which can be obtained.

Successful attempts have also been made to evaluate the resolution test-photographs by means of the density-relief method.

6.6 *Precision measurements*

6.6.1 PROFILE TESTING. The *silhouette method* is generally used for testing profiles. When a test-object is observed under a microscope or by means of a projector, and also when the photomicrographs are evaluated, it is unfortunate that in most cases the silhouette image obtained is not "sharply" defined, the details cannot be

detected clearly, and therefore it is impossible to make accurate measurements. The lack of sharpness is due to the blurred density outline at the edges of the profile, which, because of the thickness of the test-object, is caused by irradiation, diffraction, etc. It is therefore difficult to determine directly the radius of the rounding off or the roughness of the surface of an agate point (Fig. 86a) or the depth of the notch at the edge of the photomicrograph. The accuracy of measurement of the profile can, however, be increased by placing an equidensity, i.e., a curve of equal density, at the boundary of the profile (Fig. 86b). The photographs which are reproduced here do not show this advantage as clearly as is actually the case in practice, because silhouette photographs always appear more contrasty in a print than in the original.

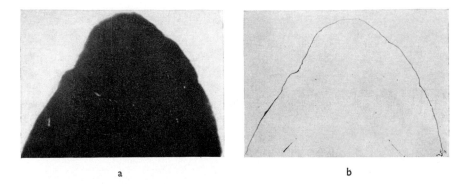

a b

Fig. 86. (a) Profile image of an agate point (enlarged 100 ×). (b) Equidensity of (a).

As *Lehmann* and *Wiemer* (1953) have demonstrated in their studies, this method shows itself to particularly great advantage in tests of wear and tear and wearing out. Good results have been achieved by the use of equidensities, so that the tests were extended to photographs of *profiles of the threads of screws*. Here again a substantial improvement was achieved in comparison with direct measurements of the profile.

6.6.2 THE TESTING OF SURFACES. The fact that equidensities can be used in all cases in which a blurred density outline renders the interpretation of measuring marks difficult prompted an investigation into the use of the equidensity method for photographs of surfaces which were produced by the *light-section* process by means of a surface-testing instrument (*Schmaltz*, 1936). The results obtained by *Lehmann* and *Wiemer* (1953) can be regarded as successful, because an equidensity achieves that which can only be aimed at but which can never attained in practice with the light-section method, namely of making the slit so narrow that a thin contour line is produced as a section of light on the surface. The width of the slit in the apparatus must be kept to the minimum so as to be able to focus sharply on one edge of the light-section: in this way of course, no line can be obtained.

94

6.6.3 GENERAL REMARKS. The examples given undoubtedly show that the new method of testing affords considerable advantages: in spite of this it is also necessary to put forward the necessary criticisms. We shall investigate, for instance, the conditions which obtain in the testing of profiles. In this case, in certain circumstances, there are places at which changes occur in the density outline at the edges of the profile as the result of irradiation. Thus it is necessary to find out more precisely what evidence an equidensity can offer regarding the shape of a profile. From the results of these investigations it will then depend on how suitable the equidensity photographs are for measuring the profile of an object, e.g., for determining the radius of an agate point (Fig. 86a). Since these questions always arise in measurements made with profile projectors, this limitation of the equidensity method for testing profiles does not detract from its superiority in general use (resolution of detail, better recognition of irregularity, roughness, etc.) over the simple silhouette method (see also *Krug* 1954).

6.7 *Photoelasticity*

An obvious use of equidensities lies in photoelasticity in which interference phenomena have to be evaluated. *Schwieger* and *Haberland* (1955/56) have shown that by using equidensities, stresses can be determined with sufficient accuracy solely from *isoclinic* photographs.

In photoelastic experiments model materials of low optical efficiency are used for photographing the *isoclinic* lines from which the main lines of stress can be derived. Plexiglass which has good elastic properties and is practically entirely free from stresses when unloaded, has proved itself to be a particularly useful substance for this purpose. Unfortunately, however, in general, no, or only a few of the *isochromatic lines* which are necessary for estimating the main stress occur in plexiglass, and thus it is necessary to measure differences of $m < 1$ in optical path, i.e., to analyse the elliptically polarized light which emerges behind the model, by means of an optical polarization method (e.g., by point-by-point compensation). Since these methods are very tedious a further model made of a synthetic resin of high optical efficiency is usually employed when photographing isochromatic lines. *Schwieger* and *Haberland* started out with the idea of doing without the second model and of obtaining the positions of *equal shear stress* τ_{xy} and also of the *equal maximum shear stress* τ_{max}, directly by photographing the isoclinic lines. Since equidensitometry furnishes the places of equal density on the photogram and therefore also the *places of equal light intensity*, the optical birefringence can be calculated point by point: the intensity distribution I behind the analyser is known, and a function of the birefringence produced by the tensions and of the angle α between a direction of the main tension and that of the polarizer. Thus if the *isoclinic lines* in each of two equidensities are split up (Fig. 87) the places of equal light intensity are obtained, so that if the angle α longitudinally to the equidensities is known, the difference in the optical path Δm can be determined with sufficient accuracy.

The said authors have also shown how equidensities themselves can be produced as curves of *equal stress* in which τ_{xy} = const.,(Fig. 88), as well as directly in the form of curves of *constant principle shear stress* (τ_{max} = const.). Here the equidensities are relatively wide, corresponding to the small gradient. In many cases these wide curves are sufficiently accurate to meet the requirements encountered in model ex-

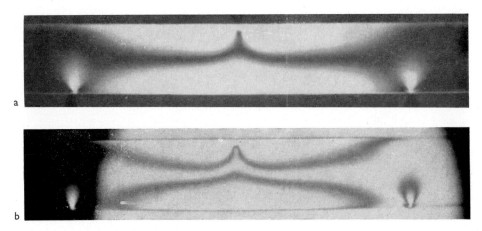

Fig. 87. (a) Isoclinic lines of a plexiglass beam with a single load in the centre. (b) Equidensities of (a).

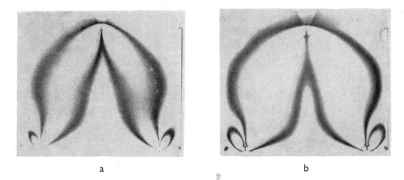

Fig. 88. Equidensities as lines of constant shear stress (τ_{xy} = const.). (a) Single load $P = 70$ kp. (b) Single load $P = 130$ kp.

periments in photoelasticity, especially as, owing to the variation in their width, they give additional information about the *stress gradients*. If more accurate results are aimed at, equidensities of any required sharpness and in any number can also be obtained by the method previously described for these studies.

These methods are of great importance especially for the investigation of transient stresses (impact-stresses, etc.), if glass which is a material possessing constant elastic and optical properties is to be used (*Träger* 1962, *Schwieger* and *Träger* 1962).

In many applications of ionising radiations the time-integrated spatial distribution of the energy absorbed by a substance (absorbed dose) is needed, and this is frequently represented in a form of isodose curves. For the preparation of such isodose curves, especially in clinical radiation therapy, the exposure of a photographic film used as a detector in the plane of interest, followed by the evaluation of the resulting density distribution by means of the equidensity method, presents great advantages over methods of measuring individual points with expensive dosimeters. *Kölle, Eichhorn* and *Degenhardt* (1956) were the first to describe this method for producing isodose curves around radium applicators. *Andreas* (1956, 1959), *Caha* and *Prokes* (1957), and *Alexi, Schikarski* and *Günther* (1962) employed this method in gynaecological radium dosimetry, and *Caha, Benes, Prokes* and *Dadok* (1955) demonstrated with a scintillation dosimeter that the isodose curves produced photometrically around radium applicators actually were, within the limits of error of measurement, isodose curves. *Rakow* (1959, 1960a) has described a method of calibration which obviates the necessity of measuring the dose from each curve with an ionization dosimeter, and which eliminates many photographic errors. By exposing the film in a scattering medium (e.g., in water or a paraffin phantom) the error due to the dependence of the angle of the photographic reaction can be avoided. Further applications are given by *Dolezel* 1961, *Sahatchiev* and *Pentchev* 1965.

The use of film dosimetry in combination with equidensitometry for planning in moving beam-therapy in cancer therapy was used by *Matschke* and his collaborators [(*Huber, Barth, Matschke, Iglauer* (1956), *Matschke, Nauber* and *Welker* (1962), *Matschke, Welker* and *Nauber* (1963) *Matschke* and *Welker* (1963), *Matschke* and *Richter* (1963)] and rendered universal by *Rakow* (1959, 1960a, 1964, 1965) by the development of a method of calibration and also by demarcating the limits of the method by means of systematic theoretical and experimental studies of the sources of error. *Keller* (1964) in a review article also recommends this method. *Klapper* and *Geske* (*Klapper*, 1962, *Klapper* and *Geske*, 1964,) have used this method for measuring a betatron X-ray field and for analysis in non-destructive testing. *Seidel* and *Wulff* (1965) have also used equidensitometry to compare dosimetric methods of determining the dose at interfaces inside non-homogeneous phantoms on irradiation with high-speed electrons. *Tsien* and *Robbins* (1966) have used this method universally in radiation therapy as well as *Lescrenier, Stacey* and *Jones* (1965), who use a photo printing machine to produce equidensities.

It may also be of interest to note that as early as 1924 *Holfelder, Bornhauser* and *Yaloussis* produced isodose curves by a photographic method using a different printing process.

As a typical example we shall now describe the use of this process with the methods of calibration described by *Rakow* (1962) in moving-beam therapy with a Co-60-γ teletherapy unit, and discuss the advantages and the difficulties of the method (1965). Figure 89 shows on the left the radiogram of a pendulum irradiation (Co-60-γ radiation from the Theratron Junior unit: field size at rotation centre 3·5 cm \times 8 cm,

focus-rotation centre distance 55 cm, maximum depth 8 cm, angle of the pendulum ±55°). Beside this is given the middle strip of the "calibration radiogram" (Theratron Junior, fixed field, focus-surface distance 47 cm, field size at a depth of 8 cm: 3·5 cm × 8 cm). Both the radiograms were produced on the same film (before ex-

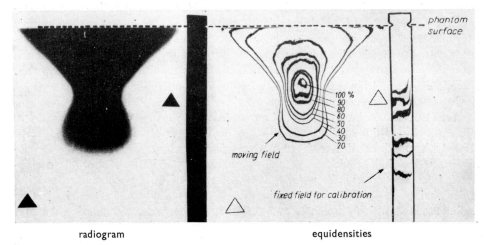

radiogram equidensities

Fig. 89. Estimation of the dose of an equidensity.

posing, a large sheet of film was cut up) in order to eliminate variations between one sheet of film and another and developed and fixed simultaneously to keep development errors to a minimum. The subsequent equidensity processing was also carried out simultaneously (the corresponding equidensities are on the right-hand side of the figure). The dose corresponding to an equidensity is found from the depth of the position of the equidensity in the calibration radiogram. The dose rate at various depths in the central beam of a fixed field, can be measured very easily with ordinary ionization chambers, or may be taken from tables.

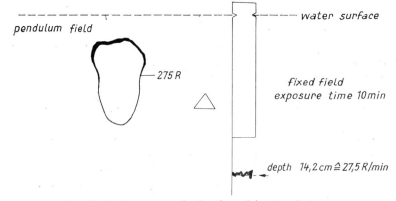

Fig. 90. Isodose curves of a Co-60 pendulum irradiation.

In the example given in Fig. 90 the equidensity was produced at a depth of 14·2 cm corresponding to 27·5 R/min × 10 min = 275 R. By means of a suitable technique the equidensities can also be placed in the position of a pre-selected density, i.e. of a pre-selected dose (cf. the percentage isodose curves in the figure) (*Rakow*, 1962). A brief comparison with other methods reveals the practical advantages of this method. In Fig. 91 the continuous isodose curves which were determined photographically can be seen on the left-hand side, whilst the right-hand side shows the values of individual ionometric measurements (a total of about 150 points of measurement), and the isodose curves which have been constructed from these points. The result with the photographic method is obtained with two radiograms (about 15 min) fol-

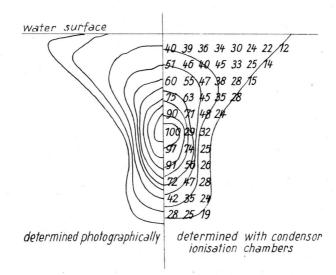

Fig. 91. Isodose curves obtained with Co-60 pendulum irradiation.

lowed by processing (exposures, development, fixing washing and drying). In routine operations about 3 h are required to obtain the 9 curves of which only 15 min are taken up at the radiation source. On the other hand, single ionometric measurements require about 150 × 6 min, equal to 15 h just for making the measurements. If 150 single detectors (condensation chambers, luminescence detectors, glass dosimeters, etc.) are used at the same time, then apart from say an exposure of 10 min, an additional 150 × 3 min equal to $7\frac{1}{2}$ h are necessary for setting up and measuring, and about 10 min for constructing the curves. In addition the support of the detectors and the detectors themselves can produce errors by means of their scattering or absorption influence on a neighbouring detector. Because of the great length of time involved, a considerably smaller number of points of measurement is used in practice, and this again impairs the accuracy of the total measurement. In the production of isodose curves for pendulum irradiation about several axes this drawback is even more ap-

parent. With the method of measuring single points considerable errors may also be incurred by the inexact positioning of the detectors, the influence of the detectors on each other, and by the construction of the isodose curves between the single measured values. By means of symbols (cf. the triangles in Figs. 90 and 91) the geometrical uncertainties in the photographic method are shown to be of the order of 0·5 mm in magnitude. Nevertheless, when the dose gradients are small, i.e. when the density gradients are small, the curves already become fairly wide [e.g., with a FSD (focus-to-skin distance) of 50 cm the resulting equidensities can already become 10 mm in width]. However, by previously copying on to a hard photographic material, curves of the old quality can be obtained.

If the greater expenditure in money and time incurred with the usual method be disregarded for once, then with this method, even with 150 points of measurement, i.e. about 1 point of measurement per cm^2, a not inconsiderable error still arises in constructing isodose curves, as is already evident on the right-hand side of the picture. This is because ionization chambers can be really large in extent (about 7 mm \varnothing as compared with say the 0·01 mm \varnothing of a silver bromide grain) which has a very disadvantageous effect, particularly on the measurement of large dose gradients, e.g., at the edge of a field or in grid irradiation, etc.

The following conclusion is arrived at: even if the absolute accuracy of methods of measuring individual points were greater than that of the photographic method, for the reasons outlined above a greater degree of accuracy is to be expected from the photographic method. Moreover, films placed at any distances can be exposed simultaneously, thus yielding three-dimensional isodose curves. This method also avoids development errors and any non-linearity of the characteristic curve is of no importance. The time-consuming photometering of films with densitometers or expensive automatic photometers has been replaced by a simple laboratory procedure without having to use specific apparatus. The great difficulty of this method lies in the dependence of the photographic reaction on the quantum energy of the incident radiation, i.e. in photographic dosimetry itself, and not in the equidensitometric method. Even when the same irradiation conditions are chosen for calibration purposes, as with the radiogram in question, a change in the quantum energy distribution within the beam gives rise to certain errors. In this case the equidensities are not isodose curves, because the absorption of radiation energy per Roentgen unit may be different at different depths. The magnitude of the errors has been discussed in detail by *Rakow* (1962, 1963, 1965) and also at the time by *Keller* (1963), and in extreme cases it can amount to $\pm 40\%$, but as a rule it is of the order of $\pm 5\%$. An exact description is beyond the scope of this book, for the correct use of the method a study of *Rakow*'s work (1963, 1965) is recommended.

The work of *Rakow* (1960b) and *Tschaschel* (1961) has opened up a further field of application for equidensitometry by increasing the accuracy of evaluation of grey wedge spectrograms in γ-spectrometry. *Hollstein* and *Münzel* (1961) have developed this process into a method of quantitative analysis, which, however, does not take into account any possible errors due to the *Schwarzschild* effect and the non-proportionality of the light-energy emitted from the luminescent screen. *Melcher* and *Gerth*

(1964) and *Melcher* (1966) have used the same process for a very cheap method of recording variations in the impulse density of halogen GM counters photographically.

The analysis of radiological photographs (*Rakow*, 1959) gives further information about the image content, but in X-ray diagnosis it is not the curves of equal intensity, but rather the curves of the same gradient which are of interest, because, on account of superpositions on the object, good evaluation is impossible in the case of equidensities (*Rakow* and *Zapf*, 1962).

X-ray diagnosis can be improved by the use of the colour equidensity method (cf. sections 3.4 and 4.3). Figure 30 gives an example in which the radiograph of a bone has been converted into a colour equidensity image.

The evaluation of macro- or micro-autoradiograms offers great advantages in a few cases, especially when the isotope distribution gradients are very large (*Rakow*, 1962, *Leder*, 1961).

Rakow and *Ernst* (1961) have used equidensitometry for evaluating isoimpulse density lines produced by a photographic recording scanner (which records the geometrical distribution of a radioactive isotope in a living body, from outside the body).

By employing a special method of calibration (*Rakow*, 1963), all errors which are attributable to the *Schwarzschild* effect, conditions of development, variations in film sensitivity, impulse statistics, non-proportionality of the electronics and of the recording instrument, etc. are eliminated (see also *Vebersik*, 1964).

6.9 *Other fields of application*

6.9.1 THE DETAIL REPRODUCTION OF PHOTOGRAPHIC MATERIALS. The density of one of the reflected details in a photographic material is only determined exclusively by the quantity of incident light if its magnitude does not fall below a limiting value. This signifies that a relation is set up between the density and the size of the detail, which can be represented as the contrast transfer function of the material. Simultaneously with this photometric falsification, the resemblance between the object and image also becomes geometrically distorted. *Hodam* (1960, 1961) investigated the behaviour of various photographic materials in reproducing small isolated details of 10–120 nm by means of the density-relief method. The test images (lines and squares) were used both in the form of a dark detail on a light background (absorption detail), as well as a light detail on a dark background (emission detail). Figs. 92a and b show the interference contrast image of the density relief above and the interference image in oblique section below. The lower photograph shows in particular that in the absorption test the height of the relief, i.e., the reflection density decreases more rapidly and to a greater extent with the size of the object than in the emission test. If the same test is used for different materials, very considerable differences appear when the photographs are evaluated quantitatively. Whereas in some particular emulsions the heights of the profile already coincide with details of 60 nm in both the tests, with other, usually very high-speed emulsions, a discrepancy can be established, even with details of 200 nm.

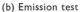

<div style="text-align: center;">(a) Absorption test (b) Emission test</div>

Fig. 92. The behaviour of a photographic material in reproducing isolated details. Interference photo-micrographs of the density relief. Above: horizontal section. Below: oblique section.

6.9.2 THE IMAGING PROPERTIES OF OPTICAL SYSTEMS. In order to arrive at critical characteristic quantities for the practical performance of a photographic objective the latter is used to form an image of a test-object, and this image is usually studied either directly in the form of an aerial image, or in the form of a photographic image. Since a photometric evaluation is the main object of the exercise, it is advantageous to use a one-dimensional grating of ascending frequency for the test-object. An image

of the latter is formed by the lens undergoing test and is enlarged with a microscope objective and photometered [see, for instance, *Rosenhauer* and *Rosenbruch* (1957)]. This photometry is usually carried out with electronic aids, resulting in the contrast-transfer function and the transfer function as the quotient of the measured contrasts of image and object.

According to *Märker* (1963) this photometry can be carried out in an analogous manner to the method of spectral photometry described in section 6.3.1 if a linear density grey wedge is placed in front of the photographic material and the image is equidensitometered. An equidensity of this type is reproduced in Fig. 93. It results

Fig. 93. Modulation transfer function in the form of an equidensity.

from the image formed by the grating of 8 groups of lines, each group consisting of 3 lines. The position frequencies in the plane of the image of the system tested amount to 6, 9, 13, 20, 30, 45, 67 and 100 lines/mm. The drop in the amplitudes of the equi-

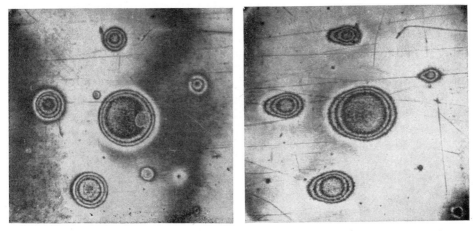

(a) Good objective (b) Decentered objective

Fig. 94. The light distribution of small points.

103

Fig. 95. The density relief of a diminishing chess-board pattern obtained with a photographic lens in various out-of-focus stages.

densities Δy corresponds to the decrease in the modulation transfer function M. The following relation exists between M and Δy:

$$M = \frac{10^{a\Delta y} - 1}{10^{a\Delta y} + 1},$$

where a is the contrast of the grey wedge employed. The modulation transfer function can therefore be obtained by direct measurement of the amplitude y. The use of the density-relief method has the advantage of two-dimensional photometry for evaluating

the test-object, thus enabling figures of any shape to be employed. In addition to purely photometric criteria changes in shape can also be drawn into the argument when making criticisms (*Hodam*, 1958, 1959). Thus in Fig. 94a it can be seen from the number of interference fringes which occur that the smallest point will not be reproduced in its full density: moreover, the thickness of the interference fringes shows the gradient of the image formation of the edges, which gradient becomes steeper on stopping down. A great advantage of this method is its sensitivity in studies of the light-distribution outside the optical axis, both with decentering (Fig. 94b) as well as when the image is out of focus (Fig. 95).

VII. THE ELECTRONIC RECORDING OF EQUIDENSITIES

7.1 *General aspects*

The progressive trends in the development of modern electronics nowadays enables photometric values of measurement to be detected electrically, or their spatial and chronological relations to be recorded. This is particularly true of photoelectric processes and it also suggested the idea of producing equidensities electronically. For special problems it is necessary to be able to place equidensities in any required intensity region. Dioptrical-photographic methods (cf. section 3.1) attractive as they are because they yield very remarkable results with the minimum outlay on apparatus, are difficult to manipulate for these purposes. The density-relief method (cf. section 3.3) gives families of equidensities which, however, are previously determined by the principle of interference (distance between the contours $\lambda/2$): moreover, in practice, the method is likely to be limited to small areas.

Recourse can be had to electronic processes for solving such problems (the desired equidensities over large areas) and various ways of doing this are discussed, one of which involves the direct projection of equidensities on to the luminescent screen of a *Braun* tube. This method was employed in 1953 in America by *Fowler* et al., and consists in the use of ordinary means of transmitting a radio image with the insertion of an intensity filter which functions by means of the tube characteristics. *Lohmann* (1956) suggests obtaining the equidensities by means of a clipper followed by a differential stage, or of rendering them visible on a *Braun* tube. Moreover, by multiplying mixing in a hexode, the photographic positive-negative process can be imitated directly or realized electronically. This procedure is followed, for example, in the *Institut für Optik und Spektroskopie*, and has probably the best prospects of success. As long as they are used in conjunction with a cathode-ray tube, these methods give a quick general survey of the shapes of the equidensities, but the inaccuracy of the reproduction, and particularly the imperfect geometry of the cathode-ray tube render them inadequate for making more precise measurements: i.e., an equidensity image on its own does not enable topographical details in the original to be identified perfectly. On the other hand, these methods, by employing purely electronic switching elements, give a direct optical representation of equidensities which have constantly to be converted into one another. This suggests the use of this method in combination with *television microscopy*. Another means is to use mixed electronic and mechanical components, and will be described in section 7.2.

Whereas photographic processes are applicable exclusively to photographic images, with electronic methods it is also possible to photometer microscopic, telescopic and such like *aerial images* directly without the intermediate use of photography, and to make the equidensities visible on the screen of a *Braun* tube. These equidensities can then be transformed into one another simply by means of electronic switching

devices, or several equidensities can be rendered visible at one and the same time. Whilst from the outset photographic equidensitometry methods function in two dimensions, all electronic processes work primarily in *one dimension* and can only be extended to the second dimension by employing a large number of lines.

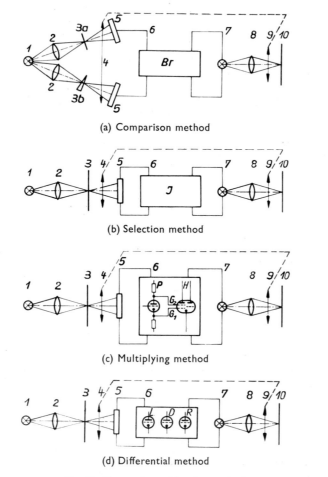

(a) Comparison method

(b) Selection method

(c) Multiplying method

(d) Differential method

Fig. 96. Electronic equidensity methods.

In operating the electronic production of equidensities, four main methods of solving the problem (Fig. 96) have to be distinguished: (a) comparative; (b) selective, (c) multiplying and (d) differential processes. The first three methods have already been described in the years 1952/53 (*Lau* and *Krug*, 1952, *Fowler*, 1953), whereas a process with a differential stage did not become known until later (*Lohmann*, 1957). All the methods can be combined with mechanical or electronic (optical, microscopic and telescopic television) scanning methods. The results obtained in all

cases likewise consist of equidensities which are either written photographically or are produced visually on a viewing screen.

The comparative electronic equidensity method consists in scanning the image and comparing it continuously with a specific density (brightness) which can be adjusted e.g. by means of a step-wedge. The electronic circuit is laid out in such a way that all the density and brightness values respectively, above or below the adjusted value, block the amplifier and are not reproduced. This type of method is probably the simplest one for obtaining absolute values for the equidensities, since such methods are independent of voltage fluctuations and of instabilities in the light source. The principle block circuit for such a set-up is indicated in Fig. 96a in which *1* is the light source, *2* are lenses, *3a* is the photographic image, *3b* the grey wedge, *4* the scanning device, *5* two multipliers, *6* the amplifier with the bridge circuit *Br*, *7* the light source which is controlled by the voltage which is set up, *8* a lens, *9* the composition with 4 synchronously running images, and *10* the photographic plate. In *1 Fowler* and his collaborators used a *Braun* tube for scanning the images, this tube being synchronized with a second *Braun* tube in place of those inserted in *7, 8, 9,* and *10*. The circuit in *6* is however only set up in order to suppress all the points in *3a* which have densities lower than those adjusted in *3b*. This one-sided limitation leads to isophotal contours (black-and-white boundaries) and not to equidensities in our sense of the word. The isophotal contour densitometer was developed for solving photometric problems in studies of the sun and solar corona. The method is independent of gradients. *Lohmann* (1957) has also made reference to isophotal contours. They can easily be produced optically by television, the sinusoidal intensity distribution on the photocathode, for example, being deformed by the characteristic line of a clipper into a trapezoidal signal with rounded corners. These signals can be used for reproducing isophotal contours in the form of black-and-white edges on the viewing screen. The position of the contours can easily be altered by changing the bias on the grid (shifting the characteristic line). *Lohmann* has succeeded in obtaining equidensities from the black-and-white boundary which is difficult to measure, by differentiating and rectifying the trapezoidal signals before modulating the brightness distribution on the screen. A block diagram of such an arrangement is given in Fig. 96d. The complex *6* consists of a limiter *L*, a differential stage *D* and a rectifier *R*. The multiplying and selective electronic equidensity methods were discussed by the authors as early as 1952.

The multiplying method is an electronic modification of the dioptrical-photographic equidensity method in which the equidensities are obtained by combining a negative and positive of the image. In a transparency, the transmissions of the positive *P* and the negative *N* are known to multiply each other, so that equidensities are formed in those places where *P* and *N* have approximately the same transmittance — everywhere where the transmission of *N* is greater or less than that of *P*, little or no light passes through, and the image disappears (*10*). The conversion of this process into an electronic one is reproduced purely diagrammatically in Fig. 96c. Here the complexes *1–5* and *7–10* can be regarded either as purely electronic (*4, 5* Vidicon or such like, *7, 8, 9, 10 Braun* tubes) or mechanico-electrical (*4* mechanical image

108

analysis, *9* synchronous mechanical image synthesis). If the elements denoted by *6* are imagined to be removed, then a pure image transmission of *4* (photographic, microscopic or other image) would take place in accordance with *10* (photographic plate or viewing screen). The signal from *5* is however processed by a multipole tube *H* (hexode) in such a way that it is led once to the grid G_2 and in reverse phase to grid G_2 via a phase reversal stage *P*. The signals on G_1 and G_2 behave like a positive and negative of image *3*. Accordingly multiplying mixing takes place in the hexode, thus producing a signal in *7* which is comparable with an equidensity. The use of certain variable switching elements in the grid circuits G_1 and G_2 enables the equidensities to be placed in any desired intensity regions. An arrangement which works in accordance with this process is being prepared. The process (like the differential method named in 96d) is independent of gradients.

The selective method (Fig. 96b) is based on the principle that an image is taken (negative photograph, transparency, microscope or television image) and is transmitted (by receiving or reproducing it electro-mechanically or purely electronically) and an intensity filter placed in the transmitter, filters out one, and in theory any, narrow range of intensity in the image. This causes certain intensities *I* and *dI* from the intensity range running from I_0 in the image to be thrown into relief in the form of strong equidensities. The main principle of this is embodied in the block diagram shown in Fig. 96b. If, to begin with, we disregard the intensity filter *6*, the complexes *1–5* and *7–10* can be conceived to be either purely electrical (*4*, *5* Vidicon or the like, *7–10* Braun tubes) or mechanico-electrical (*4*, *9* synchronous mechanical image analysis or synthesis). The intensity filter can be built up in various ways: it can contain a limiter with diodes, or specially connected electron tubes or thyratrons can be used (so-called "current gates"). The simplest and most modern method of tackling the problem of an electronic intensity filter is to use a modified multivibrator. The purpose of all these circuits is to block the transmitter when the equidensities lie beyond the chosen limits, so that only a more or less narrow range of intensity $I \pm dI$ is recorded.

Krug and *Schusta* (1958) have given a detailed description of electronic equidensitometry. In the meantime the authors have become acquainted with other work covering the use of electronic isophotometers, microdensographs and similar apparatus for two-dimensional photometry. This work includes that of *Armellini* 1954, *Möhler* and *Pierce* (1957), *Hariharan* and *Bhalla* 1959, *Hallows* (1961), *Vancouleurs*, *Gribeval* and *White* 1965 and also that of *Miller, Parsons* and *Kofsky* (1964). In 1953 *Michelson* published a very detailed description of an automatic-recording compensating isophotometer for use in astrophysics.

J. F. Fisher and *J. G. Gershon-Cohen* (1958) have, with the aid of television components, produced colour equidensities from standard black-and-white material by projecting, for instance, an X-ray image on to a colour cathode-ray tube. The colour change is due to the fact that when the video voltage *V* increases from 0 to 100%, the three primary colour systems of the tube are controlled in different ways. When $V = 0\%$ the blue system is bright and when $V = 50\%$ it goes dark; the green system is dark when $V = 0\%$ and $V = 100\%$ and is bright when $V = 50\%$; and the red

system increases from $V = 50\%$ (dark) to its greatest brightness when $V = 100\%$: thus a grey wedge is changed into the colours blue–cyan–grey–yellow–red.

7.2 *The equidensograph*

7.2.1 DESCRIPTION OF THE APPARATUS. A method employing mechanical and electronic components has been developed in the *Institut für Optik und Spektroskopie* (*Schusta* 1954). Although it does not enable the record to be viewed immediately it can, however, be used for selecting families of equidensities or single equidensities and recording them photographically.

An image of 0·1 mm in size of a light source L_1 is projected by means of the microscope objective O_1 on to the photographic plate P_1 (Fig. 97) which contains the photograph to be studied and which will in future be called the original plate.

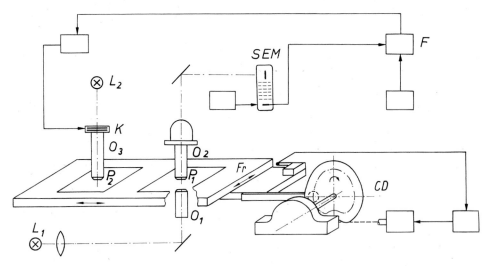

Fig. 97 Diagram of the functioning of the equidensograph.

The rays of light transmitted by P_1 are then led through a similar objective O_2 after being deflected repeatedly and magnified 300 times, and strike the light-sensitive layer of an SEM (secondary electron multiplier). The voltage which is set up at the working resistance of the SEM is fed to the input of an electronic filter F, the function of which is to give up a rectangular impulse at the output of the filter when the voltage at the input has reached a certain value. This boost in voltage which lasts for a definite space of time causes the *Kerr* cell K, which when it is not in operation is blocked by two crossed Nicols, to open for the duration of the impulse, and both this light and light from a second light source L_2 are passed through the lens O_3 and can be united to form a point of light of 1 mm in size on a second, as yet unexposed, photographic plate (P_2). Both the plates P_1 and P_2 are held rigidly together by means of

110

a frame, and when the intensity of the light transmitted by P_1 has reached a certain value, P_2 is always blackened in the corresponding place. The frame *Fr* is moved uniformly to and fro between the two objectives by means of the curved disc *CD*; in other words, the original plate is scanned linearly and at the end of every line is shifted perpendicularly by an amount equal to the width of a line. Because the electronic filter *F* only responds to a previously adjusted input voltage which corresponds to a definite light intensity, images of the lines of equal density, that is to say, equidensities of the original plate are formed on plate P_2.

In order to be able to form 3 different equidensities from the original plate on plate P_2 in one operation, three equal electronic groups with a common input and output are connected in parallel. For the sake of clarity, only one of these groups is represented in Fig. 98. The working point of the second tube which can be adjusted

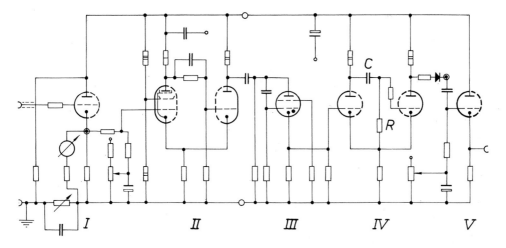

Fig. 98. Diagram of the connections.

continuously by means of a potentiometer, determines which one of the equidensities is to be portrayed at the time. The last but one stage, *V* a double tube in a monomultivibrator circuit, influences the width of the impulse by means of the time constant *RC*. Thus 3 different widths corresponding to the 3 different equidensities can act on plate P_2. These dots are so small that an observer can only perceive that the lines of the three equidensities are different in density. Stage *II* which consists of a double tube in a familiar *Schmitt* trigger circuit gives a brief impulse at a grid voltage which has to be adjusted previously. This impulse is converted into a fine needle impulse by the following thyratron *III*, and is used to control the next multivibrator stage *IV*. In the output tube *V* of an anode base stage, all 3 impulses are combined and led to a *Kerr* cell. Several highly stabilized power supply units increase the accuracy of the equipment. By going through the original plate *3* once again, 3 more

111

equidensities can be brought into focus and thus a total of 6 different equidensities can be recorded on plate *2*.

The plate can be scanned using 1800 or 900 lines as desired, the scanning time being adjusted by switching the mechanism from $\frac{1}{2}$ to 2 h. The mechanical part of the equidensograph consists of a *Zeiss* rapid photometer which has undergone a welcome addition in the form of an electronic device. Fig. 99 shows the entire construction including the electronic device. The photosensitive part is carefully screened off so that work can be performed in full daylight. In Fig. 100 the assembly of the separate electronic parts is condensed into a block circuit diagram.

Fig. 99. The general appearance of the equidensograph.

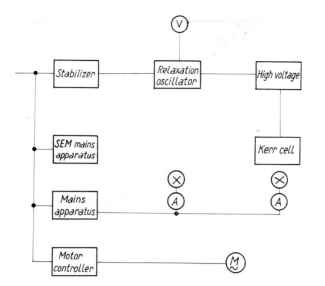

Fig. 100. Block diagram of the equidensograph.

7.2.2 THE RESULTS. A section of spherical interference rings is given as an example in Fig. 101a (cf. Fig. 6). Below this photographic image are shown two equidensity images of the same section (Fig. 101b, c). One of the equidensities (b) lies at both sides of the interference bands. The other equidensity (c) is chosen such that it lies exactly at the minimum density. Thus, there is only one curve per interference ring which only gives a slight indication of being split up in accordance with local differences: both the inner and outer rings are completely suppressed since here the minima do not lie so low down.

The line scanning and dotted structure can be identified in the figures. The line scanning of the original causes the number of details covered to drop when the lines run parallel to the density gradient. This is a property common to every kind of image analysis and would also be found again in the suggestions made at the outset with the *Braun* tube. If necessary this defect can be remedied by taking several photographs with the original plate placed at different angles.

Figure 102 shows the original and the equidensities of crossed interference fringes. All three equidensities were recorded simultaneously in one operation. The distances between the individual equidensities are so great that they can conveniently be measured.

The original photograph of a solar corona and the corresponding triple equidensities can be seen in Fig. 103. The photograph of the corona was taken on a high-speed, coarse-grain plate, and therefore the equidensities do not appear as exact line drawings, but as aggregation of dots. In theory, each silver grain in the photographic plate should record 3 equidensities respectively, because all the equidensities coincide in every contrast position. In all the equidensity photographs conclusions

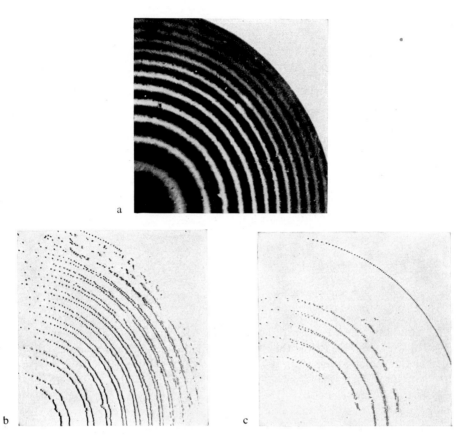

Fig. 101. *Newton's* rings. (a) Photograph (b,c) Electronic equidensities in different regions of density

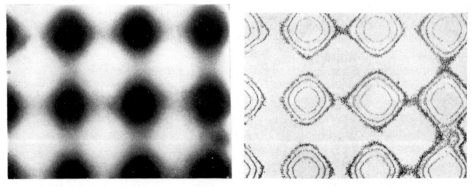

(a) Original (b) A family of equidensities

Fig. 102 Crossed interference fringes (cf. also Fig. 34 and section 5.1.).

of an intensity filter J. Only very definite voltages which can be selected beforehand are transmitted, and they then control another television receiver tube, B_2. Here again the line screens of B_1 and B_2 must run synchronously for the reasons already mentioned. Lines of equal density, i.e. equidensities are again recorded on the viewing screen of B_2. To achieve better image resolution, screens with a much larger number of lines than is usual in ordinary television were produced. When the degree of electronic amplification is sufficient, the output stage of the television set can be modulated directly.

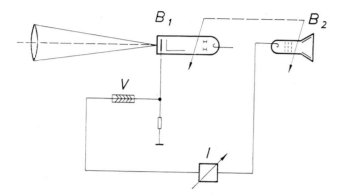

Fig. 107. Basic diagram of aerial image equidensities.

7.6 The Tech-Op/Joyce Loebl isodensitometer

Workers at *Technical C_ration Research* in Massachusetts have developed a system which, when used with the Mark III CS microdensitometer made by *Joyce-Loebl* of Gateshead, England, automatically compiles equidensity or isophote contour plots [*C. S. Miller, F. G. Parsons,* and *I. L. Kofsky* (1964)]. The instrument, which is shown in Fig. 108, measures the micro-densities on the negative in a series of successive parallel scans, divides them into discrete ranges by means of a mechanical commutator, and simultaneously prints them in a simple code that denotes the direction in which the optical density is changing and from which the isodensity contours are generated. The scanning and write-out tables are linked together by a ratio arm (for the scanning direction) and stepping gears (for advancing the scan lines) that determine the enlargement of the equidensity plot.

The coding marks (which are made by a ball-point pen) are simply the segment of a line, a series of closely-spaced dots, and a blank space; these three symbols are all that is needed to indicate unambiguously whether the optical density of the scanned sample is increasing or decreasing. The pen is programmed to repeat the three-step cyclic code dash-dots-space, dash-dots-space, etc., as long as the density is increasing, and reverses to space-dots-dash for decreasing density. The micro-density at any point on the transparency can be found by counting the number of contour interval steps, starting from the known density at a standardization point.

regarding the line scanning can be arrived at from the dotted record. The more horizontal the tangent to the equidensity curve becomes, the greater is the separation between the dots. In the limiting case in which the tangent is absolutely horizontal, no recording takes place. In order to record these parts of the image correctly, the plate has to be rotated through 90° and the operation repeated once more.

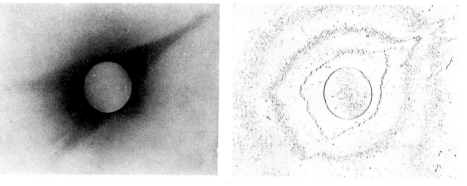

(a) Original (b) A family of equidensities

Fig. 103. Solar corona.

7.3 Television equidensities

Another important field of application was the study of the information content of a television image. Here again equidensitometry appeared to be a suitable method of investigating and judging the image contents. In solving this problem an ordinary television set was used, the only difference being that an intensity filter developed by one of us was inserted. Part of the image voltage from the anode circuit of the image output stage was disengaged via an impedence transformer at the grid of the input tube of an intensity filter. This filter consisted mainly of a limiter stage, into the cathode circuit of which an oscillator voltage of 26 Mc/sec was coupled. This frequency was chosen because it corresponded to the intermediate frequency of the amplifier in the television set. The limiting of the input stage is carried out in the usual way. It follows as closely as possible the grid voltage zero and amounts to only a few millivolts. A countervoltage in the grid circuit of the input tube enables the image voltage required for selecting the equidensity, to be compensated. A narrow region is cut out of the image voltage, which can range from 0 to 100 V. This region is amplified in the intermediate frequency amplifier, demodulated, and connected to the cathode of the viewing tube through the output stage. The equidensity which has been adjusted by means of the countervoltage appears on the viewing screen. Figure 104 shows a diagram of the basic principles of the variable intensity filter. Figure 105 represents the original picture on the television screen and three equidensities of consecutive densities. Observation of these images reveals that the information content of the picture gradually dis-

Fig. 104.
Basic diagram of the intensity filter.

Fig. 105. Television equidensities. Original with three different equidensities.

appears with decreasing density. With these pictures it should be remembered that a short time must elapse between taking the photographs to enable the set to be adjusted. The movement of the object makes it impossible to bring the four pictures into exact register.

7.4 Television microscope equidensities

A scanning pattern is produced by the usual means (line and image deflection) on the viewing screen of an image-point-scanning tube T_1 (Fig. 106) and is projected on to the object P by means of the microscope objective O. A second set of lenses K focuses the rays on to the sensitive layer of an SEM, M. The fluctuating light-intensities are converted into voltage fluctuations, and are amplified by an amplifier and led to the intensity filter J. Here only very definite voltages which correspond to a previously selected intensity are transmitted and they control a television tube T_2 on the viewing screen of which lines, which correspond to constant densities in the microscope image, appear. The lines as well as the image deflections of both the tubes T_1 and T_2 must run synchronously in order to avoid distortions of the image. The image-point-scanning tube T_1 is operated at a high anode voltage because the great degree of enlargement produced by the optics greatly reduces the intensity of the light. The intensity filter corresponds to the filter in the television equidensitometry unit, and, as already described, can be adjusted continuously to permit equidensities of any desired density to be recorded.

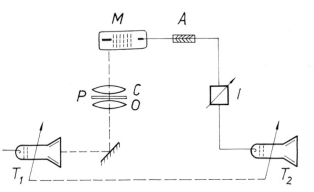

Fig. 106. Basic diagram of the television microscope equidensities.

7.5 Aerial image equidensities

An enlarged image is produced by a telescope (Fig. 107) on the active layer of a television camera tube (Vidicon, Orthicon, etc.) B_1. The very weak changes in voltage in the tube B_1 corresponding to the variations of light in the image in the telescope are amplified to the required extent by a suitable amplifier, and filtered out by means

regarding the line scanning can be arrived at from the dotted record. The more horizontal the tangent to the equidensity curve becomes, the greater is the separation between the dots. In the limiting case in which the tangent is absolutely horizontal, no recording takes place. In order to record these parts of the image correctly, the plate has to be rotated through 90° and the operation repeated once more.

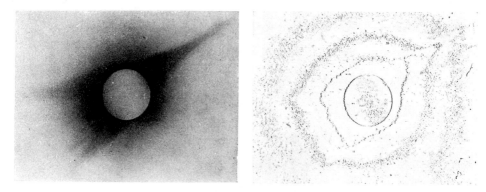

(a) Original (b) A family of equidensities
Fig. 103. Solar corona.

7.3 *Television equidensities*

Another important field of application was the study of the information content of a television image. Here again equidensitometry appeared to be a suitable method of investigating and judging the image contents. In solving this problem an ordinary television set was used, the only difference being that an intensity filter developed by one of us was inserted. Part of the image voltage from the anode circuit of the image output stage was disengaged via an impedence transformer at the grid of the input tube of an intensity filter. This filter consisted mainly of a limiter stage, into the cathode circuit of which an oscillator voltage of 26 Mc/sec was coupled. This frequency was chosen because it corresponded to the intermediate frequency of the amplifier in the television set. The limiting of the input stage is carried out in the usual way. It follows as closely as possible the grid voltage zero and amounts to only a few millivolts. A countervoltage in the grid circuit of the input tube enables the image voltage required for selecting the equidensity, to be compensated. A narrow region is cut out of the image voltage, which can range from 0 to 100 V. This region is amplified in the intermediate frequency amplifier, demodulated, and connected to the cathode of the viewing tube through the output stage. The equidensity which has been adjusted by means of the countervoltage appears on the viewing screen. Figure 104 shows a diagram of the basic principles of the variable intensity filter. Figure 105 represents the original picture on the television screen and three equidensities of consecutive densities. Observation of these images reveals that the information content of the picture gradually dis-

Fig. 104.
Basic diagram of the intensity filter.

Fig. 105. Television equidensities. Original with three different equidensities.

116

appears with decreasing density. With these pictures it should be remembered that a short time must elapse between taking the photographs to enable the set to be adjusted. The movement of the object makes it impossible to bring the four pictures into exact register.

7.4 *Television microscope equidensities*

A scanning pattern is produced by the usual means (line and image deflection) on the viewing screen of an image-point-scanning tube T_1 (Fig. 106) and is projected on to the object P by means of the microscope objective O. A second set of lenses K focuses the rays on to the sensitive layer of an SEM, M. The fluctuating light-intensities are converted into voltage fluctuations, and are amplified by an amplifier and led to the intensity filter J. Here only very definite voltages which correspond to a previously selected intensity are transmitted and they control a television tube T_2 on the viewing screen of which lines, which correspond to constant densities in the microscope image, appear. The lines as well as the image deflections of both the tubes T_1 and T_2 must run synchronously in order to avoid distortions of the image. The image-point-scanning tube T_1 is operated at a high anode voltage because the great degree of enlargement produced by the optics greatly reduces the intensity of the light. The intensity filter corresponds to the filter in the television equidensitometry unit, and, as already described, can be adjusted continuously to permit equidensities of any desired density to be recorded.

Fig. 106. Basic diagram of the television microscope equidensities.

7.5 *Aerial image equidensities*

An enlarged image is produced by a telescope (Fig. 107) on the active layer of a television camera tube (Vidicon, Orthicon, etc.) B_1. The very weak changes in voltage in the tube B_1 corresponding to the variations of light in the image in the telescope are amplified to the required extent by a suitable amplifier, and filtered out by means

of an intensity filter J. Only very definite voltages which can be selected beforehand are transmitted, and they then control another television receiver tube, B_2. Here again the line screens of B_1 and B_2 must run synchronously for the reasons already mentioned. Lines of equal density, i.e. equidensities are again recorded on the viewing screen of B_2. To achieve better image resolution, screens with a much larger number of lines than is usual in ordinary television were produced. When the degree of electronic amplification is sufficient, the output stage of the television set can be modulated directly.

Fig. 107. Basic diagram of aerial image equidensities.

7.6 *The Tech-Op/Joyce Loebl isodensitometer*

Workers at *Technical Operation Research* in Massachusetts have developed a system which, when used with the Mark III CS microdensitometer made by *Joyce-Loebl* of Gateshead, England, automatically compiles equidensity or isophote contour plots [*C. S. Miller, F. G. Parsons,* and *I. L. Kofsky* (1964)]. The instrument, which is shown in Fig. 108, measures the micro-densities on the negative in a series of successive parallel scans, divides them into discrete ranges by means of a mechanical commutator, and simultaneously prints them in a simple code that denotes the direction in which the optical density is changing and from which the isodensity contours are generated. The scanning and write-out tables are linked together by a ratio arm (for the scanning direction) and stepping gears (for advancing the scan lines) that determine the enlargement of the equidensity plot.

The coding marks (which are made by a ball-point pen) are simply the segment of a line, a series of closely-spaced dots, and a blank space; these three symbols are all that is needed to indicate unambiguously whether the optical density of the scanned sample is increasing or decreasing. The pen is programmed to repeat the three-step cyclic code dash-dots-space, dash-dots-space, etc., as long as the density is increasing, and reverses to space-dots-dash for decreasing density. The micro-density at any point on the transparency can be found by counting the number of contour interval steps, starting from the known density at a standardization point.

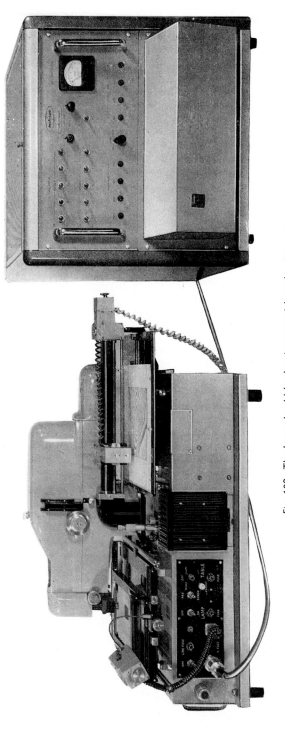

Fig. 108. The Joyce-Loebl Isodensitracer with analog computer.

In the *Joyce-Loebl* design, density is measured by null-balancing it against the reading from a continuous grey wedge which is moved across a second optical beam. The double-beam feature of the instrument allows the density increment step to be conveniently varied, by adjusting the transmission distribution along the comparison wedge. For example, a wedge with a constant density gradient extending over a range of 0·72 units, when incrementalized into 36 equally-spaced steps will produce an equidensity plot in which each contour line is spaced 0·020 units from its neighbour. A wedge with a variable gradient, designed with the displacement of each density proportional to the logarithm of the exposure which would produce that density in the developed film, can be used to generate plots on which the contours are equally spaced in log-exposure; here the wedge is serving as an analog element that linearizes the *H* and *D* curve of the photographic emulsion.

Contour plots thus corrected are isophote diagrams only if the brightness of the scene over the whole field has been faithfully reproduced by a non-vignetting camera lens through a non-absorbing atmosphere, conditions which rarely occur in practice. With a further "analog-computer" addition to the equidensitometer, such transmission losses can be restored automatically, provided, of course, that the spatial dependence of the lowering of irradiation in the plane of the film is known. This second correction is made by sensing the position of the microdensitometer beam on the negative and applying the appropriate compensating voltage to a motor that drives the brushes contacting the commutator that incrementalizes the exposures. (It is necessary, of course, that the optical density of the negative be first converted to relative incident light flux before these transmission corrections can be made.) A photograph of this "second-generation" version of the scanning isophotometer is given in the above reference, along with examples of isophote and equidensity print-outs.

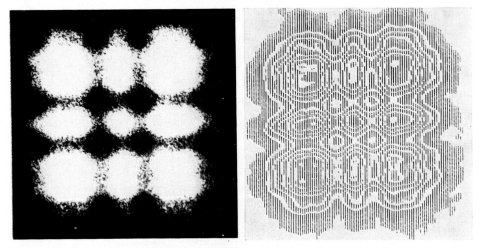

(a) Original (b) Equidensities

Fig. 109. Example of a density map taken with the Isodensitracer.

In practice, the instrument can be operated with density increments as low as 0·004 units when the scanning slit is made large enough to average over the natural grain of the photographic film. This aperture should be stepped less than its own width between new scan lines, to make the equidensity "image" isotropic in accordance with the usual rules of sampling theory. The maximum practical mechanical output/input magnification is 2000 : 1; if there are different enlargements along the two perpendicular axes the isodensity or isophote plot becomes astigmatic, and detail in the subject under study is often quite interestingly brought out. Since the output of the system is a compilation of individual microdensitometer scans, the time required to produce an equidensity or isophote plot is proportional to the total length of the lines that it contains and inversely proportional to the rate at which the instrument can null-balance the density modulations in the sample. Usually a single 25 cm line can be scanned in about 30 sec, so that a plot composed of 100 individual lines takes roughly 1 h to produce.

An example of a density map written with the isodensitracer is shown in Fig. 109. In this presentation the increasing film density is blank-dots-dash. The width of the original negative image (diffraction pattern of a square aperture photographed slightly out of focus) is 0·5 mm and the size of the slit is 10 μm × 10 μm.

7.7 *Comparison with the photographic and the density-relief methods*

The basic disadvantage of the electronic method still continues to be the line scanning and the consequent limitation of the image elements, which means that the information content of the original can never be exhausted completely. Rapid photometry is, however, entirely satisfactory for many purposes, e.g. for photometering illumination distributions. It is, however, solely a question of the expense involved in making this scanning as fine as desired and thus approaching the quality obtainable with the photographic method.

The electronic method provides a direct means of placing an equidensity at a previously selected density: with the dioptrical-photographic method this is usually dependent on various circumstances which are very difficult to control, because the densities appear most readily in the proximity of large gradients.

What is even more important is that the electronic method enables an entire family of equidensities to be placed at previously selected densities, a result which can only be achieved in several steps with dioptrical-photographic methods. The density-relief method likewise yields families of equidensities, but practical difficulties are encountered when it is used for large areas.

Whilst the dioptrical-photographic and the density-relief methods function *two-dimensionally* from the outset, all electronic processes are primarily *one-dimensional*: they can only be extended to the second dimension by using a large number of lines. (see also *Hiller* 1959).

VIII. CONCLUSION

One-dimensional photometry of a photographic plate has become of enormous importance in fields of science of all descriptions. The requisite methods are comparatively simple and are easily carried out. On the other hand, although *two-dimensional* photometry is acknowledged to be an urgent requirement, the methods involved are usually very complicated and unsatisfactory. *Equidensitometry* offers a very simple method. Every photogram represents a density distribution which can be represented by equidensities in a similar way to the isohypses (contour lines) of a landscape. The use of isodensitometry discloses the information content of pictures in a form which hitherto has very seldom been employed. The assignment of photometric values to images affords entirely new possibilities of evaluating photograms even in those cases in which this used to be left solely to the eye, with all its imperfections. The authors believe that in the various parts of this book they have shown that such sections through the density distribution as represented by equidensities are a useful aid in evaluating the information content of photographs. The photographic plate has proved itself here to be an astonishingly useful measuring device, although admittedly at the same time, its limitations have come to light. The limits of equidensitometry lie precisely where the definition of the density in an element of area ceases or becomes uncertain.

The authors hope that the present material will provide a new instrument of research.

IX. BIBLIOGRAPHY

The figures in italics refer to the page and plate numbers of this book

ALEXI, P., SCHIKARSKI, W. and GÜNTHER, R., *Eichphantom für die Durchführung eines Verfahrens zur quantitativen Vermessung von Isodosiskurven radioaktiver Präparate* (*Calibration phantom for use in the quantitative measurement of isodose curves of radioactive preparations*), GFP document 1 130 530 of class 219, group 18/02 laid open to public inspection May 1962. *97*

ALTMANN, J. H., Microdensitometry of high resolution plates by measurement of the relief image, *Photogr Sci and Eng*, 10, 156, (1966). *33*

ANDERSON, F. Th., Microscopie électronique sur film en couleurs Eklacircom lumière du jour (Electron microscopy on Eklacircom daylight colour film), *Bull Microsc Appl*, 6, 142, (1950). *34*

ANDREAS, H., Isodosenphotogramme von Strahlungsquellen (Isodose photograms of radiation sources), *Strahlentherapie*, 101, 416, (1956). *97*

ANDREAS, H., *Dosierungsfragen bei der gynäkologischen Radiumbestrahlung* (*Dose problems in gynaecological radium therapy*), Leipzig 1959, 82, *18, 97*

ANGERER, E. VON, *Wissenschaftliche Photographie* (*Scientific photography*), Leipzig 1952, 151. *18, 33*

ANGERSTEIN, W., KRUG, W. and RAKOW, A., Eine Methode zur Erzeugung farbiger Röntgenbilder (A method of producing coloured X-ray images), *Fortschr Geb Röntg Strahl, Nukl Med*, 100, 257, (1964), *36*

ANGERSTEIN, W., see Rakow, A., Angerstein, W., Krug, W. and Kankelwitz, B.

ARENS, H., Über die Theorie des Sabattier-Effektes (The theory of the Sabattier effect), *Z wiss Photogr*, 44, 44, 51, 172, (1949); 45, 1, (1950). *18, 20*

ARMELLINI, G., Observationi fotometriche e polarimetriche della corona solare durante l'éclisse totale di sole del 25. febbraio 1952 (Photometric and polarimetric observations of the solar corona during the total eclipse of the sun on the 25th February, 1952, *Corona isophotes, Rc*, 17, 11, (1954). *109*

BANIG, T. and MIELER, W., Die Anwendung der Äquidensitometrie zur verbesserten Wiedergabe von Chromosomen (The use of equidensitometry for improving the reproduction of chromosomes), *Z Kinderheilk*, 90, 54, (1964). *87*

BARTH, L., see Huber, R., Barth, L., Matschke, S. and Iglauer, E.

BARTZ, K., see Kirchhoff, H. and Bartz, K.

BENES, O., see Caha, A., Benes, O., Prokes, V. and Dadok, J.

BETHGE, H., Zur Anwendung der Äquidensitometrie in der Elektronenmikroskopie (The application of equidensitometry to electron microscopy), *Phys. Verh.* 12, 153, (1961). *88*

BETHGE, H., see Heidenreich, J., Bethge, H. and Ruess, U.

BHALLA, M. S., see Hariharan, P. and Bhalla, M. S.

BILLINGS, D. E., see Fowler, F. E., Johnson, D. S. and Billings, D. E.

BLANKE, W., see Lohmann, A. and Blanke, W.

BOHNEN, H. D., see Pohlmann, R., Bohnen, H. D. and Brinkmann, R.

BORNHAUSER, O., see Holfelder, H., Bornhauser, O. and Yaloussis, E.

BREIDO, I. I. and Chebotereva, T. P., The equidensity method based on the Sabattier photographic effect and its application to the photometry of nebulae and comets, *Mitt Astron Hauptobs Pulkovo*, 24, part 4 (Russ. with Engl. sum.). *66*

BRINKMANN, R., see Pohlmann, R., Bohnen, H. D. and Brinkmann, R.

BROMNIKOVA, N. M., Photometry of the Seki-Lines comet by the equidensity method, *Mitt Astr Hauptobs Pulkovo*, 24, part 4 (1965) (Russ. with Engl. sum.). *66*

CAHA, A., BENES, O., PROKES, V. and DADOK, J., Srovnani isodosnich krivek v okoli gynaekologickych aplikatoru ziskanych pomoci scintilacniho intensimetru a fotograficke metody (A comparison of isodose curves in the neighbourhood of gynaecological applicators which were obtained with the aid of a scintillaıion intensimeter and by means of a photograhic method), *Sb ceskoslovenskych praci gynaekologicko-onkologickeho sjezdu s mezinarodni ucasti v prace*, 188, (1955). *97*

Caha, A. and PROKES, V., Neketére novejsi zpusoby stanoveni prubehu isodosnich krivek v okoli Ra aplikatoru a pomerného rozlozeni davek v dopadvem poli pri RTG therapii (Some recent methods of determining (a) the shape of isodose curves on the periphery of radium applicators and (b) the relative dose distribution in the field of incidence in X-ray therapy), *Cslká Rentg*, 11, 190, (1957). *97*

CALLENDER, R. M., Photographische Darstellung von Leuchtdichteverteilungen (The photographic representation of luminance distributions), *Lichttechnik* 13, 403, (1961). *61*

CARDOSO DOS SANTOS, E., see Pires Soares, J. M, and Cardoso dos Santos, E.

COSSLETT, A., Some applications of equidensitometry in interference microscopy, *J Roy Microsc Soc*, 84, 385, (1965). *38, 74*

CROY, O., *Photomontage*, Halle/Saale 1950, 83. *15, 27*

DADOK, J., see Caha, A., Benes, O., Prokes, V. and Dadok, J.

DEGENHARDT, K. H., see Kölle, W., Eichhorn, H. J. and Degenhardt, K. H.

DOLEŽEL, M., Uziti sabattierova jevu pri stanoveni izodoznich krivek (Use of the Sabattier effect for obtaining isodose curves around radium preparations), *Cslká Rentg*, 15, part 4, 280, (1961). *97*

DYSON, J., Examining machined surfaces by interferometry. *Engng*, 179, 274, (1955). *11, 37*

EBERHARD, G., Photographic-photometric investigations, *Phys, Z.*, 13, 288, (1912); *Publs Astr Obs Potsdam*, 26, part 1, (1926). *18*

EDENHOLM, B. and INGELSTAM, E., Some recent advances in the interferometric study of surface shape. *Ingevensk Arch Stockholm*, 26, 5, 194, (1954). *11, 83*

EDENHOLM, B., JOHANSSON, C. E. and INGELSTAM, E., A combined multiple-beam and two-beam microinterferometer for surface topography measurements. *Proc Brussels Coll "Optics in Metrology"* (May 1958), London 1959. *11*

EICHHORN, H. J., see Kölle, W., Eichhorn, H. J. and Degenhardt, K. H.

EICHLER, W., Chromogenentwickelnde Photomaterialien für Röntgen- und Gammastrahlen (Colour developing photographic materials for X-rays and gamma-rays), *Wiss Photogr*, Darmstadt 1958, 596,. *34*

ENGELBRECHT, J., see Schmidt, H. and Engelbrecht, J.

ERNST, H., see Rakow, A. and Ernst, H.

FEHR, J. W., Solarization (Pseudosolarization), *Camera*, 22, 221, (1944). *18*

FISHER, J. F. and GERSHON-COHEN, J., Television techniques for contrast enhancement and colour translation of roentgenograms, *Am J Roentg*, 79, 342, (1958). *109*

FOWLER, F. E., JOHNSON, D. S. and BILLINGS, D. E., An isophotal contour densitometer, *J Opt Soc Am*. 43, 1, 63, (1953). *106, 107*

GEHRCKE, E. and LAU, E., Über Erscheinungen beim Sehen kontinuierlicher Helligkeitsverteilungen (Phenomena in seeing continuous brightness distributions) *Z Sinnesphysiol*, 53, 351, (1921). *9*

GERACI, J., How to solarize prints, *Amer Photogr*, p 20, Sept. 1952. *18*

GERSHON-COHEN, J., see Fisher, J. F. and Gershon-Cohen, J.

GERTH, E., Analytische Darstellung der Schwärzungskurve unter Berücksichtigung des Schwarzschild-Effekts (Analytical representation of the characteristic curve with reference to the Schwarz schild-effect), *Z wiss Photogr*, 59, 1, (1965). *21, 61*

124

GERTH, E.: Ein äquidensitometrisches Verfahren zur Registrierung des zeitlichen Verlaufs der Lichtintensität (An equidensitometric method for recording the relation between time and the light intensity). *Feingerätetechn, 16*, 558 (1967).*56*

GERTH, E., see Melcher, H. and Gerth, E., also Kröber, K. and Gerth, E.

GESKE, C.., see Klapper, F. and Geske, G.

GREIF, H., Die Erzeugung von Leuchtdichteniveaulinien in photographischen Aufnahmen (The production of luminance contour lines in photographic images), *Wiss Z Hochsch Elektrotechn Ilmenau*. 5, 241, (1959). *15*

GREIF, H., Die Isohelie—eine Ergänzung der Äquidensitometrie (Posterizing (Isohelie)—a supplement to equidensitometry *Bild Ton*, 14, 112, (1961). *15*

GREIF, H., Photographische Darstellung von Leuchtdichteverteilungen (The photographic representation of luminance distributions), *Lichttechnik, Berlin*, 13, 53, (1961). *15*

GREIF, H., Die Auswertung photographischer Aufnahmen mit Hilfe der Tontrennung (The evaluation of photographic images with the aid of tone separation), *Technik*, 16, 602, (1961). *15*

Greif, H., Die Anwendung des Isohelie-Verfahrens zur Bildverbesserung (The use of the posterization method for improving photographs), *Bild Ton*, 15, 162, (1962). *15*

GRIBOVAL, P., see Vancouleurs, de, G.

GÜNTHER, R., see Alexi, P., Schikarski, W. and Günther, R.

HAAS, H. and NEULEIB, H., Über ein spektroskopisches Verfahren zur Bestimmung der Rotationsdispersion (A spectroscopic method of determining rotation dispersion), *Feingerätetechn*, 11, 47, (1962). *56*

HABERLAND, G., see Schwieger, H. and Haberland, G.

HALLOWS, R. L., Electronic brightness contouring, *J Soc Motion Pict Telev Engrs*, 70, 23, (1961).*109*

HARIHARAN, P. and BHALLA, M. S., Contour-mapping microdensitometer, *J Sci Instrum*, 36, 192, (1959). *109*

HEIDENREICH, J., BETHGE, H. and RUESS, U. Zur objektiven Auswertung von Auflösungstest-Aufnahmen (The objective evaluation of resolution tests), *Proc 3. Europ Reg Conf El Mir*, Prague 1964, Vol. 1, 125. *90*

HEINZ, W., Zur quantitativen Auswertung von Schwärzungsverläufen nach dem Äquidensitenverfahren (The quantitative evaluation of density relations by the equidensity method), *Inaugural-Dissert Math.-Nat. Fak Freie Univ Berlin*, 1960. *55*

HESS, G., see Lau, E. and Hess, G.

HEYMER, G., Über ein vereinfachtes Verfahren der Isohelie (A simplified posterizing method), *Veröff wiss Photo-Lab AGFA*, 6, 239, (1939). *15*

HILLER, Chr,. Vergleichende Untersuchungen über verschiedene Verfahren der Äquidensitometrie (Comparative investigations of various methods of equidensitometry), *Optic aller Wellenlängen (Optics of all Wavelengths)*, Berlin 1959, 322. *121*

HODAM, F., Über die Benutzung der Schwärzungsplastik zur Prüfung photographischer Objektive (The utilization of density relief for testing photographic objectives), *Feingerätetechn*, 7, 110, (1958). *105*

HODAM, F. and LAU, E., Mannigfaltigkeit der Probleme der Gebrauchsleistung von Objektiven (The variety of problems in the practical performance of objectives), *Optic*, 16, 586, (1959). *105*

HODAM, F., Die Schwärzungsplastik als meßtechnisches Hilfsmittel (The use of density relief for making practical measurements), *Acta IMEKO 1958*, Budapest 1960, 351, *105*

HODAM, F., Über das Verhalten photographischer Materialien bei der Wiedergabe kleiner isolierter Details (The behaviour of photographic materials in reproducing small isolated details), *Optik*, 17, 521, (1960). *101*

HODAM, F., Zweidimensionale mikrophotometrische Auswertung photographischer Bilder (The two-dimensional microphotometric evaluation of photographic images), *Optik und Spektroskopie aller Wellenlängen (Optiks and spectroscopy of all wavelengths)*, Berlin 1961, 232. *33, 101*

HODGE, P. W. and BROWNLEE, D. E., Photographic isophotometry of galaxies, *Publ Astron Soc Pac*, No. 461, (1966). *66*

HÖGNER, W., Der Sabattier-Effekt als hervorragendes Hilfsmittel in der Äquidensitometrie (The Sabattier-effect as an outstanding aid in equidensitometry), *Fotografie*, 17, 457, (1963). *18*

HÖGNER, W. and RICHTER, N., Morphologische und photometrische Untersuchungen an extragalaktischen Nebeln in 5 Farbbereichen mit Hilfe der Äquidensitenmethode (Morphological and photometric studies of extragalactic nebulae in 5 colour regions with the aid of the equidensity method), *Jenaer Rdsch*, 9, 1, (1964). *62*

HÖGNER, W., and RICHTER. N., Sonnenkorona-Isophotometrie auf äquidensitometrischem Wege (Isophotometry of the corona by means of equidensitometry), *Mber Dtsch Akad Wiss*, 7, 258, (1965). *63*

HÖGNER, W. and RICHTER, N., Equidensitometry—The new technique of astronomical isophotometry. *Jena Review*, 11, 315, (1966). *63*

HÖGNER, W., see Löchel, K. and Högner, W., also Richter, N. and Högner, W.

HOLFELDER, H., BORNHAUSER, O. qnd YALOUSSIS, E., Über die Intensitätsverteilung der Röntgenstrahlen in der Körpertiefe (The intensity distribution of X-rays in the depths of the body). *Strahlentherapie*, 16, 412, (1924). *97*

HOLLSTEIN, M. and MÜNZEL, H., Anwendung der Graukeilmethode auf die Gamma-Spektroskopie (The application of the grey-wedge method to gamma spectroscopy), *Atompraxis*, 7, 407, (1961). *100*

HUBER, R., BARTH, L., MATSCHKE, S. and IGLAUER. E., Eine Methode zur direkten Handdosis-Messung bei der Röntgen-Tiefentherapie hilusnaher Bronchial-Carcinome (A method of direct manual dose measurement in the deep X-ray therapy of bronchial carcinomata near the hilum), *Strahlentherapie*, 99, 79, (1956). *97*

HÜBNER, G., see LÜHR, F. and HÜBNER, G.

HUBRIG, W. H., Die Anwendung des Äquidensitenverfahrens zur Erhöhung der Genauigkeit bei röntgenographischen Gitterkonstantenbestimmungen (The use of the equidensity method for increasing the accuracy in determinations of X-ray lattice constants), *Zfk-Wf 24*, Dresden 1962. *56*

HUBRIG, W. H., Die Anwendung des Äquidensitenverfahrens zur Erhöhung der Genauigkeit bei Abstandsmessungen von Röntgeninterferenzen (The use of the equidensity method for increasing the accuracy of measurements of the distances of X-ray interference fringes *Z wiss Photogr Photophys, und Photochem*, 58, Nr. 1–4,(1964). *55*

HUBRIG, W. H., see Schenk, M. and Hubrig, H.

HUND, F., Einführung in die theoretische Physik (Introduction to theoretical physics), Vol. III *Optics*, Leipzig 1951, p. 59, *45*

IGLAUER, E., see Huber, R., Barth, L., Matschke, S. and Iglauer, E.

INGELSTAM, E., An optical uncertainty principle and its application to the amount of information obtainable from multiple-beam interferences, *Ark Fys*, 7, 309, (1953). *12*

INGELSTAM, E., see Edenholm, B, and Ingelstam, E.

INGELSTAM, E., see Edenholm, B., Johansson, G. E. and Ingelstam, E.

ITO, K., see Yotsumoto, H. and Ito, K.

JOBIN, M. M., YVON, Equidensitomètre (Equidensitometers), *Rev Opt théor instrum*, 13, 179, (1934) *9*

JOHANNESSON, J., see Lau, E. and Johannesson, J.

JOHANSSON, C. E., see Edenholm, B., Johansson, C. E. and Ingelstam. E.

JOHNSON, D. S., see Fowler, F. E., Johnson, D. S. and Billings, D. E.

JONES, C. H., see Leschenier, C., Stacey, A. J. and Jones, C. H.

126

KADLA, Z. I., The fluttering of the globular cluster M. 13 determined from equidensity curves, *Astron J* XLIII, 124, (1966). *66*

KANKELWITZ, B., KRUG, W. and LAU, E., Kontraststeuerung photographischer Bilder durch Buntentwicklung (Increasing the contrast of photographic images by multi-colour development), *Optik und Spektroskopie aller Wellenlängen (Optics and spectroscopy of all wavelengths)*, Berlin 1962, 288. *36*

KANKELWITZ, B., see Rakow, A., Angerstein, W., Krug, W. and Kankelwitz, B.

KELLER, H. L., Die Probleme der photographischen Dosismessung bei konventionellen und ultra-harten Strahlungen (The problems of photographic dose measurement when using conventional and ultra-hard radiations), *Strahlentherapie*, 122, 174, (1963). *100*

KELLER, H. L., Filmdosimetrie in der Strahlentherapie (Film dosimetry in radiation therapy), *Radiologe*, 4, 272, (1964). *97*

KIND, E. G., Photographische Herstellung von Äquidensiten (The photographic production of equi-densities), *Arbeitstagung Optik, Jena 1954 (A working meeting on optics, Jena 1954)*, Berlin 1954, 117. *18, 37*

KIND, E. G., Herstellung von Einkornschichten aus normalen Emulsionen durch Einfärben (The preparation of single-grain layers from standard emulsions by dyeing), *Z wiss Photogr*, 53, 266, (1959). *23*

KIND, E. G., see Lau, E., Kind, E. G. and Roose, G.

KLAPPER, P., Photographische Äquidensiten zur Charakterisierung des Betatronstrahlenkegels und ihre Anwendung in der Defektoskopie (Photographic equidensities for characterizing the betatron radiation cone, and its use in non-destructive testing. *Manuscript* 1962. *97*

KLAPPER, F. and GESKE, G., Bestimmung der Intensität und der Endenergie der Bremsstrahlung eines Betatrons mit Hilfe von Ionisationskammern (Determination of the intensity and final energy of the radiation due to the retarding of particles in a betatron by means of ionisation chambers). *Exp Tech Phys*, 2, 331, (1964). *97*

KLEBER, W., Äquidensitometrie von Debye-Scherrer-Diagrammen (The equidensitometry of Debye-Scherrer diagrams) *Z Kristallogr*, 108, 316, (1956). *55*

KLÖTZER, J., Ein Beitrag zur Erklärung des Sabattier-Effektes (A contribution in explanation of the Sabattier effect), *Z wiss Photogr*, 50, 386, (1955). *20*

KOELLBLOED, D., The isophotometer of the Astronomical Institute of the University of Amster-dam, *Bull Astr Inst Netherl* 18, 62, (1965), *66*

KÖLLE, W., EICHHORN, H. J. and DEGENHARDT, K. H., Die Herstellung von Isodosentafeln mittels einer photographischen Methode (Photographic production of isodose tables), *Probl Erg Biophys Strahlenbiol*, Leipzig 1956, 205. *97*

KOFSKY, I. L., see Miller, C. X., Parsons, F. G. and Kofsky, I. L.

KOHAUT, A., Das Interferenzmikroskop, ein vielseitiges Meßgerät (The interference microscope, a versatile measuring instrument), *Z angew Phys*, 1, 165, (1948). *32, 37*

KOHN, H., Elektronische Bestimmung der Isogradienten (The electronic determination of isogra-dients), *Exp Tech Phys*, 10, part 6, 423, (1962). *88*

KRAMER, W., Ein optisches Registrierphotometer (An optical recording photometer), *Z Naturf*, 6a, 658, (1951). *66*

KRÖBER, K. and GERTH, E., Sensitometrie der Doppelbelichtung in Anwendung auf eine Film-überblendung (The sensitometry of double exposures and its application to film dissolves), *Bild Ton*, 17, 98, (1964). *21, 61*

KRÖBER, K. and GERTH, E., Äquidensitometrische Bestimmung des Mittelwertes und der mitt-leren Schwankung physikalischer Meßgrößen (Equidensitometric determination of the mean value and the mean variation in the data of physical measurements), *Z wiss Photogr*, 59, 38, (1965). *56*

127

KRUG, W., Die Anwendung des Äquidensitenverfahrens in der Feinmeßtechnik (The use of the isodensity method for precision measurements), *Feingerätetechn*, 3, 387, (1954). *56, 94*

KRUG, W., Das Äquidensitenverfahren (The equidensitometry method), *Arbeitstagung Optik, Jena 1954* (*A working meeting on optics, Jena 1954*), Berlin 1954, 112. *83*

KRUG, W., Bessere Wiedergabe der Oberflächenstruktur durch Zweistrahl- als durch Mehrstrahlinterferenzen (The improved reproduction of surface structure given by two-beam interference patterns as compared with multiple-beam interference patterns), *Feingerätetechn*, 4, 167, (1955). *12, 81, 83*

KRUG, W., Mehrstrahlinterferencen und Äquidensiten (Multiple-beam interference fringes and equidensities), *Optik*, 13, 25, (1956). *12*

KRUG, W., Neuere Ergebnisse der photographischen Äquidensitometrie (Recent results obtained with photographic equidensitometry), *Optik*, 15, 616, (1958). *23*

KRUG, W., Äquidensitometrie. Verfahren zur zweidimensionalen Photometrie und zur Analyse von Bildern (Equidensitometry. A method of two-dimensional photometry and of analysing images), *ATM* V, 434—8/9, (1959). *9*

KRUG, W., Überblick über die äquidensitometrischen Verfahren (A survey of equidensitometric processes). *Optik*, 16, 621, (1959). *9*

KRUG, W., Neuartige Kontraststeuerung photogrammetrischer Aufnahmen (A novel method of increasing the contrast of photogrammetric images), *Vermessungstechn*, 12, 178, (1964). *36*

KRUG, W. and LAU, E., Interferenzmikroskop für Durch- und Auflicht (An interference microscope for transmitted and incident light), *Annln Phys*, (6), 8, 329 (1951); *Technik*, 6, 122, (1951). *32, 33, 37, 73, 83*

KRUG, W. and LAU, E., Die Äquidensitometrie, ein neues Meßverfahren für Wissenschaft und Technik (Equidensitometry, a new method of measurement for use in science and technology), *Feingerätetechn*, 1, 391, (1952). *9*

KRUG, W., RIENITZ, J. and SCHULZ, G., *Contributions to interference microscopy*, Translated by J. HOME DICKSON, London 1964. *11, 74*

KRUG, W. and SCHUSTA, J., Elektronische Äquidensitenherstellung (The electronic production of equidensities), *Optik*, 15, 145, 550, (1958). *107*

KRUG, W., see Lau, E. and Krug, W., also Kankelwitz, B., Krug, W. and Lau, E., also Angerstein W., Krug, W. and Rakow, A.

KRUG, W., see Rakow, A., Angerstein, W., Krug, W. and Kankelwitz, B.

LAU, E., Kontrast und räumliches Sehen (Contrast and stereoscopic vision), *Z Arb Psychol prakt Psychol*, 11, 117, (1938). *9*

LAU, E., Das Optimum der Detailwiedergabe der photographischen Schichten und das Maximum des Geräuschpegels (The optimum detail reproduction of photographic materials and the maximum noise level), *Feingerätetechn*, 1, 298, (1952). *13*

LAU, E., Anwendung der Äquidensiten bei Mehrstrahlinterferenzen (The use of equidensities with multiple-beam interference fringes), *Feingerätetechn*, 2, 497, (1953), *81*

LAU, E., Die Äquidensiten in der Verwendung für spektroskopische Photometrie (The use of equidensities in spectrophotometry), *Exp Techn Phys*, 1, 199, (1953). *66*

LAU, E., Bildanalyse (Image analysis), *Feingerätetechn*, 5, 126, (1956). *86*

LAU, E., Schwärzungsplastik und ihre Anwendungen (The density relief method and its applications), *Tagesbericht II. Internat Koll Hochsch Elektrotech Ilmenau 1957* (*Report of a meeting: 2nd International Colloquium of the Electrical Engineering College, Ilmenau 1957*), p. 46, (1958). *31*

LAU, E., Sensitometrische Messungen bei Doppelbelichtungen mit Äquidensiten (Sensitometric measurements with double exposures with equidensities), *Optik*, 16, 623, (1959), *59*

LAU, E., Ausschöpfung des Informationsgehaltes von Schwarzweiß-Negativen (Holokopie) (Exhausting the information content of black- and white-negatives (holocopy)), *Optik*, 21, 637, (1964). *4, 26*

LAU, E., Holokopie—ein Verfahren zur vollständigen Erfassung des Informationsgehaltes photographischer Schwarzweiß-Negative (Holocopy—a method for the total recording of the information content of black- and white-negatives), *Bild Ton* 16, 258, (1963); 17, 167, (1964); 18, 194, (1965). *26*

LAU, E. and JOHANNESSON, J., Die optischen Eigenschaften photographischer Schichten (The optical properties of photographic materials), *Z Phys*, 82, 37 (1933). *27*

LAU, E. and HESS, G., Photographische Großflächenphotometrie (The photographic photometry of large areas), *Bild Ton*, 13, 71, (1960); *Optik und Spektroskopie aller Wellenlängen* (*Optics and spectroscopy of all wavelengths*), Berlin 1962, 285; *Mber Dtsch Akad Wiss*, 2, 678, (1960). *30, 66*

LAU, E. and JOHANNESSON, J., Das Optimum der Detailwiedergabe der photographischen Schichten (The optimum deatil reproduction given by photographic materials), *Z Phys*, 35, 505, (1934). *13*

LAU, E., KIND, E. G. and ROOSE, G., Photometry of Photographic Plates by interference microscopy, *Mon tech Rev*, 2, part 5, 118, (1958). *31*

LAU, E. and KRUG, W., Verfahren zur photometrischen Auswertung photographischer Bilder (A method of photometric evaluation of photographic images), *GDR P 14, 163 and 19, 785*, 12th Oct. 1952. *9, 107*

LAU, E., see Gehrcke, E. and Lau, E., also Hodam, F. and Lau, E., also Krug, W. and Lau, E., also Kankelwitz, B., Krug, W. and Lau, E.

LAU, E., RIENITZ, J. and ROOSE, G., Die Intensitätsverteilung von Zweistrahlinterferenzen und die Äquidensiten (The intensity distribution of two-beam interferences, and equidensities), *Feingerätetechn*, 2, 101, (1953). *34*

LEDER, O., Auswertung von Radiogrammen mit Äquidensiten (The evaluation of radiograms by means of equidensities), *Pflügers Arch ges Physiol*, 274, 87, (1961). *101*

LEHMANN, R. and WIEMER, A., Die Anwendung von Äquidensiten bei der Profilprüfung (The use of equidensities in profile testing), *Feingerätetechn*, 2, 171, (1953). *94*

LESCHENIER, C., STACEY, A. J. and JONES, C. H., A new method of obtaining isodose curves using film dosimetry, *Phys Med Biol*, 10, 567, (1965). *97*

LOCQUIN, M., Transposition en contrastes de couleurs des contrastes en microscopie électronique (The transformation of electronmicroscope contrasts into colour contrasts), *Bull Microsc appl*, 6, 155, (1950). *34*

LÖCHEL, K. and HÖGNER, W., Isophotendarstellung der Sonnenkorona vom 15. Februar 1961 mit Hilfe photographischer Äquidensiten (Isophote representation of the corona on 15th February 1961 by the use of photographic equidensities), *Z Astrophys*, 62, 121, (1965). *63*

LOHMANN, A., Kompensation der optischen und elektrischen Abbildungsfehler beim Fernsehen (The compensation of optical and electrical image errors in television), *Phys Verh*, 7, 140, (1956). *106*

LOHMANN, A., Fernsehoptische Äquidensitenherstellung (The optical production of equidensities by television), *Optik*, 14, 178, (1957). *107, 108*

MALY, M,. Isogradientverfahren zur Auswertung des photographischen Bildes (The isogradient method of evaluating the photographic image), *Optik aller Wellenlängen* (*Optics of all wavelengths*), Berlin 1959, 349, *88*

MÄRKER, I., Eine photographische Methode zur Messung der Modulationsübertragungsfunktion von Objektiven (A photographic method for measuring the modulation transfer function of objectives), *I. Symp Inkamera*, Prague 1963, 105. *66, 103*

MATSCHKE, S., NAUBER, G. and WELKER, K., Die Dosisverteilung bei drei verschiedenen Methoden der tangentialen Mammabestrahlung (Dose distribution with three different methods of tangential irradiation of the mamma), *Radiobiol Radiother*, 3, 365, (1962). *97*

MATSCHKE, S. and RICHTER, J., Vergleichende Untersuchungen der Dosisverteilung bei verschiedenen Methoden der Ösophagusbestrahlung (Comparative studies of the dosage distribution with various methods of irradiating the oesophagus), *Radiobiol Radiother*, 4, 385, (1963). *97*

MATSCHKE, S. and WELKER, K., Die individuelle Isodosenanpassung bei der biaxialen Pendel-bestrahlung gynäkologischer Tumoren (Individual adjustment of the isodose in the biaxial pendulum irradiation of gynaecological tumors), *Radiobiol Radiother*, 4, 401, (1963). *97*

MATSCHKE, S., WELKER, K. and NAUBER, G., Tangentiale Mammabestrahlung, 2. Mitteilung: Einfluß der Konfiguration der Mamma auf die Dosisverteilung (Tangential irradiation of the mamma, 2nd communication: The influence of the configuration of the mamma on the dose distribution), *Radiobiol Radiother*, 4, 411, (1963). *97*

MATSCHKE, S., see Huber, R., Barth, L., Matschke, S. and Iglauer, E.

MELCHER, H., Einige Versuche zur Radioaktivität (Some experiments on radioactivity), *Math Naturwiss Unters*, 19, 298, (1966). *65, 101*

MELCHER, H, and GERTH, E., Ein neues Verfahren zur photographischen Aufzeichnung und Aus-wertung des zeitlichen Verlaufs der Impulsdichte (A new method of photographically recording and evaluating the variation in the counter rate of counter tubes with time), *Atomkernenergie*, 9, 133, (1964)– *100*

MICHELSON, N. N., A compensating isophotometer, *Nachr Pulkowo*, No. 151, 69 (Russ.). *109*

MIELER, W., see Banig, R. and Mieler, W.

MILLER, C. S., PARSONS, F. G. and KOFSKY, I. L., Simplified two-dimensional microdensito-metry, *Nature*, 202, 1196, (1964). *109, 118*

MINKWITZ, G., see Schwider, J., Schulz, G., Riekher, R. and Minkwitz, G.

MOHLER, O. C. and PIERCE, A. K., A high-resolution isophotometer, *Astrophys J*, 125, 285, (1957). *109*

MÜNZEL, H., see Hollstein, M. and Münzel, H.

NAUBER, G., see Matschke, S., Nauber, G. and Welker, K.

NEULEIB, H., see Haas, H. and Neuleib, H.

NORRISH, R. G. W., see Stevens, G. W. W. and Norrish, R. G. W.

PENTCHEV, P., see Sahatchiev, A. and Pentchev, P.

PARSONS, F. G., see Miller, C. S., Parsons, F. G. and Kofsky, I. L.

PERTHEN, J., Die Oberflächen-Feingestalt (The fine structure of surfaces), *Z VDI*, 96, 855, (1954). *81*

PIERCE, A. K., see Mohler, O. C. and Pierce, A. K.

PIRES SOARES, J. M. and CARDOSO DOS SANTOS, E., The Sabattier effect in photomicro-graphy, *The Microscope*, 9, 5, (1952). *18*

POHLMANN, R., BOHNEN, H. D. and BRINKMANN, R., Theoretische Grundlagen der Äqui-densitometrie im Hinblick auf die quantitative Auswertung schalloptischer Abbildungen (Theore-tical foundations of the equidensitometry with regard to the quantitative evaluation of optical sound images), *Forschungsber Nordrhein-Westf*, Nr. 1512, 1965. *56*

PROKES, V., see Caha, A. and Prokes, V., and also Caha, A. Benes, O., Prokes, V. and Dadok, J.

RAKOW, A., Zur Anwendung von Äquidensitometrie in der Radiologie (The use of equidensito-metry in radiology), *Dtsch Gesdwes*, 14, 382, (1959). *97, 101*

RAKOW, A., Die Leistungsfähigkeit eines bequemen photographischen Verfahrens zur Darstellung von Isodosen (The efficiency of a convenient photographic method of producing isodosages), *Probleme und Ergebnisse aus Biophysik und Strahlenbiologie*, II, 121, (1960a). *97*

RAKOW, A., Ein Verfahren zur leichteren Auswertung von Graukeilspektrogrammen (An easier method of evaluating grey wedge spectrograms), *Atomkernenergie*, 5, 91, (1960b). *100*

RAKOW, A., Isodosenkurven bei der Co-60-Bewegungsbestrahlung mit einer billigen photographi-schen Methode (A cheap photographic method of obtaining isodose curves in Co-60-moving beam therapy, (Argomenti di Radioterapia con alte Energie), *Edizioni Minerva Medica*, Torino 345, (1962). *97, 99, 100, 101*

130

RAKOW, A., Verfahren zum Gewinnen eines Vergleichsbildes für die Auswertung eines mit einem Abtastgerät aufgezeichneten Bildes der flächenhaften Verteilung einer radioaktiven Strahlung (Method of obtaining a comparison image for the evaluation of an image recorded by a scanner, of the distribution in the plane of a radioactive radiation), *GFP 1.143.935.* Applied for 16th May, 1960, granted 5th Sept 1963. *97, 100, 101*

RAKOW, A., Der Wert der photographischen Bestimmung der Dosisverteilung für die Bestrahlungsplanung (The value of the photographic determination of the dose distribution in planning ray-treatment), *Radiobiol Radiother*, 6, 69, (1965). *97, 99, 100*

RAKOW, A., ANGERSTEIN, W., KRUG, W. and KANKELWITZ, B., Über Detailerkennbarkeit bei farbigen Röntgenbildern (The perceptibility of the details in coloured radiographs), *Magy Radiology XIII*, 212, (1961). *36*

RAKOW, A. and ERNST, H., Isoimpulsdichtelinien beim Photoscanning (Isoimpulse density lines in photographic scanning), *Strahlentherapie*, 114, 629, (1961). *101*

RAKOW, A. and ZAPF, K., Zur Äquidensitometrie und ihrer Bedeutung für die Bildanalyse elektronenmikroskopischer Aufnahmen biologischer Objekte (Equidensitometry and its importance in the analysis of the images in electron-microscope photographs of biological objects), *Microskopie*, 17, 217, (1962). *88, 101*

RAKOW, A., see Angerstein, W., Krug, W. and Rakow, A.

RÄNTSCH, K., Oberflächenprüfung durch Lichtinterferenz (Surface testing by light-interference), Feinmechn Präz, 52, 75, (1943). *11*

RÄNTSCH, K., Grundsätzliches zur Interferenzmikroskopie (The fundamentals of interference microscopy), *Werkstatttechnik*, 42, 434, (1952), *12, 32, 37, 75*

RASMUSSEN, E., Kg. dansk Videnskabernes Selskab Meddeel ser 23, 3 (1945). *81*

RAUCH, H., Die Anwendung von äquidensitometrischen Verfahren bei der Auswertung von Rauchfahnenphotographien (The use of equidensitometric methods for the evaluation of smokestreamer photographs), *Optik*, 16, 629, (1959). *41*

RICHTER, J., see Matschke, S. and Richter, J.

RICHTER, N., see Högner, W. and Richter, N.

RICHTER, N. and HÖGNER, W., Zur Anwendung der Äquidensitometrie auf astronomische Probleme: Morphologische und photometrische Untersuchungen an M 31, M 32 und NGC 205 (The application of equidensitometry to problems in astronomy: morphological and photometric studies of M 31, M32, and NGC 205). *Astr Nachr*, 287, 261, (1963). *61*

RICHTER, N. and HÖGNER, W., Die Anwendung der Äquidensitenmethode zur morphologischen und photometrischen Beschreibung von Kometen (The use of equidensity methods for the morphological and photometric description of comets), *Die Sterne*, 40, 11, (1964). *63*

RICHTER, N. and HÖGNER, W., Photographic isophotometry of comets by equidensitometry, *Mitt Karl Schwarzschild Observ Nr. 22*, 1964.

RIENITZ, J., Interferenzkontrastmikroskopie im Auflicht mit dem Interferenzmikroskop nach Krug und Lau (Incident light interference contrast microscopy with the Krug and Lau interference microscope), *Feingerätetechn* 2, 161 (1953). *32*

RIENITZ, J., see Krug, W., Rienitz, J. and Schulz, G.

RIEKHER, R., see Schwider, J., Schulz, G., Riekher, R. and Minkwitz, G., Robbins, R., see Tsien, K. and Robbins, R.

ROMER, W., Isohelie, eine neue Technik der bildmäßigen Photographie (Posterizing, a new technique for pictorial photography), *Camera*, p. 191, 1932; p. 2, 1938. *15*

ROOSE, G., see Lau, E., Kind, E. G. and Roose, G.

ROSENBRUCH, K.-J., see Rosenhauer, K. and Rosenbruch, K.-J.

ROSENHAUER, K., ROSENBRUCH, K. J., Ein Verfahren zur Messung der Kontrastübertragungsfunktion photographischer Objektive (A method for measuring of the frequency response of photographic objectives), *Optica Acta*, 4, 21, (1957). *103*

RUESS, U., see Heidenreich, J., Bethge, H. and Ruess, U.

SAHATCHIEV, A. and PENTCHEV, P., Photographic method of determining the dose distribution of ionising radiation (in Bulgarian), *Onkologija* (Sofia), 2, 34, (1965). *97*

SCHENK, M. and HUBRIG, H,. Zur Erhöhung der Genauigkeit röntgenographischer Methoden Gitterkonstantenbestimmungen mit Hilfe spezieller photographischer Methoden (Increasing the accuracy of radiographic determinations of lattice constants with the aid of special photographic methods), *Exp Tech Phys*, 12, 152, (1964), *55*

SCHIEL, M., *Tontrennungsverfahren der bildmäßigen Fotografie* (*Tone separation processes in pictorial photography*), Halle/Saale 1951, 57; Berlin 1954, 117. *15*

SCHIKARSKI, W., see Alexi, P., Schikarski, W. and Günther, R.

SCHMALTZ, G., *Technische Oberflächenkunde* (*Surface Technology*), Berlin 1936. *94*

SCHMIDT, H., Erfahrungen mit dem Schwärzungsplastikverfahren (Experiences with the density-relief method), *Optik*, 16, 538, (1959). *33, 34, 71*

SCHMIDT, H., Photographische Photometrie von Sternspektren mit dem Interferenzmikroskop (The photographic photometry of stellar spectra with the interference microscope), *Veröff Sternw Babelsberg*, 13, part 1, (1960a). *71*

SCHMIDT, H., Densometrie an photographischen Mikroobjekten (The densitometry of photographic micro-objects), *Photogr Korr*, 96, 137, 151, (1960b). *71*

SCHMIDT, H and ENGELBRECHT, J., Interferenzeinrichtung zur Untersuchung von Sternspektren nach dem Schwärzungsplastikverfahren (An interference device for studying stellar spectra by the density relief method), *Z Instrkde*, 66, 227, (1958). *71*

SCHNUR and FELDMANN, Die Anwendung der Äquidensitographie zur Flächenphotometrie veränderlicher Objekte (Application of equidensitography to the aerial photometry of variable objects), *Z. Astrophys*, 61, (1965). *66*

SCHRÖTER, E. H., Chromosphäre Strukturen in den Balmerlinien (Chromospheric structures in Balmer lines), *Z Astrophys*, 45, 68, (1958). *72*

SCHULT, E., Intensitätsmessungen an Interferenzerscheinungen nebst Untersuchung stehender Lichtwellen (Equidensity measurements of interference phenomena in addition to the study of stationary light waves), *Annln Phys*, Leipzig 82, 1025, (1927). *45*

SCHULZ, G., Das Steulichtverfahren der Äquidensitometrie (The scattered-light method of equidensitometry), *Feingerätetechn*, 2, 167, (1953). *27, 57*

SCHULZ, G., Brechungsindexbestimmung im Interferenzmikroskop am Beispiel des CdS (The determination of refractive index under the interference microscope, using CdS as an example), *Naturwiss*, 41, 525, (1954). *83*

SCHULZ, G., Dickenmessung dünner Objekte im Auflicht-Interferenzmikroskop (Measurement of the thickness of thin objects under the incident-light interference microscope), *Naturwiss*, 43, 31, (1956). *84*

SCHULZ, G., Bestimmung von Dicke und räumlicher Gestalt nach dem Zwei-Seiten-Verfahren (The determination of thickness and spatial configuration by means of the two-sided method), *Optik*, 13, 404, (1956). *84*

SCHULZ, G., see Krug, W., Rienitz, J. and Schulz, G.

SCHULZ, G., see Schwider, J., Schulz, G., Riekher, R. and Minkwitz, G.

SCHUSTA, J., Elektronische Herstellung der Äquidensiten (The electronic production of equidensities), *Arbeitstagung Optik, Jena 1954* (*A working meeting on Optics, Jena 1954*), Berlin 1954, 123. *110*

SCHUSTA, J., see Krug, W. and Schusta, J.

SCHWIDER, J., SCHULZ, G., RIEKHER, R. and MINKWITZ, G., Ein Interferenzverfahren zur Absolutprüfung von Planflächennormalen (I) (An interference method for testing absolute planeness (part I)), *Optica Acta*, 13, 103, (1966). *53*

SCHWIEGER, H. and HABERLAND, G., Die Anwendung der Äquidensiten in der Spannungs-optik (The use of equidensities in photoelasticity), *Bauplanung Bautechn*, 9, 71, (1955); *Wiss Z Univ Halle, Math Nat*, 4, 853, (1955); *Feingerätetechn*, 5, 65, (1956). *95*

SCHWIEGER, H. and HABERLAND, G., Die photographische Darstellung von Schubgleichen unterhalb der 1. Isochromatenordnung bei spannungsoptischen Versuchen (The photographic representation of equal stresses below the 1st isochromates order in photoelastic experiments), *Z angew Phys*, 8, 350, (1956). *95*

SCHWIEGER, H. and TRÄGER, J., Polarisationsoptische Studie über den Randstoß auf eine Kreisscheibe (Research on the marginal push against a circular disc by means of polarization optics), *Z angew Phys*, 14, 375, (1962). *96*

SEIDEL, W. and WULFF, W., Zur Dosimetrie hochenergetischer Elektronen (The dosimetry of high energy electrons), *Radiobiol Radiother* 1965. *97*

SEWIG, R., *Objektive Photometrie (Objective photometry)*, Berlin 1935 . *9*

SHARPLES, T. D., Quasi-solarization, a chemical reaction of photographic prints, with applications to pictorial photography, *J photogr Sci*, 11, 427, (1945). *9, 18*

STACEY, A. J., see Leschenier, C., Stacey, A. J. and Jones, C. H.

STEVENS, G. W. W. and NORRISH, R. G., The mechanism of photographic reversal, *Photogr J*, 78, 513, (1938). *20*

SUDBURY, P. V., Isodensitometry of Jupiter, *Astr Contr Univ Manchester*, Series III, Nr. 130, (1965). *63*

THIERY, G., L'emploi d'artifices photographiques en technique photomicrographique: le bas relief, la solarisation (The application of photographic artifices to photomicrographic technique: pseudo-plastic, solarization), *Bull Histol Appl Tech Microsc*, XXVI, 22, (1949). *15, 18*

TOLANSKY, S., *Multiple-beam interferometry of surfaces and films*, Oxford 1948. *12, 16, 80, 81, 83*

TOLANSKY, S., *The microstructures of diamond surfaces*, London 1955. *80*

TOLANSKY, S., *Surface Microtopography*, London 1960. *80*

TRÄGER, J., Polarisationsoptische Untersuchung des Randstoßes auf Scheiben (Research on the marginal push against disks by means of polarization optics), *Abh Dtsch Akad Wiss, Klasse Math, Phys, Tech* Nr. 4, 215, (1962). *96*

TRÄGER, J., see Schwieger, H. and Träger, J.

TSIEN, K. and ROBBINS, R., The photographic representation of isodose patterns by the applica-tion of the Sabattier effect, *Brit J Radiol* 39, 1, (1966). *97*

TSCHASCHEL, R., Qualitative und quantitative Gamma-Analyse niedriger Aktivitäten nach der Graukeilmethode (Qualitative and quantitative gamma-analysis of low activities by the grey wedge method), *Telefunkenzeitung*, 34, 133, (1961). *100*

URBAN, W., Beiträge zur Praxis der gerichtlichen Photographyie (Contributions to the practice of forensic photography). (*Jb Photogr Reprod Tech*, 25, 186, (1911). *15*

VANCOULEURS, G. DE, GRIBOVAL, P. and WHITE, T., A versatile isophotometer, *Publ Astr Soc Pacific*, 77, part 455, (1965); *Publ Dep Astron Univ Texas*, Series I, Vol, 1, part 8, (1965). *109*

VANSEK, V., A note on the accuracy of photographic photometry with the Schmidt-telescope, *Acta Univ Carolina, Math Phys* part 1, (1964). *66*

VEBERSIK, V., Izódozní vyhodnocování gamagramú při íntraperitoneálni aplíci radiozlata shomotou 198 (Isodose analysis of the gammagrams observed in the intraperitoneal application of gold-198). *Cslká Radiologie*, 18, 304 (1964). *101*

133

WELKER, K., see Matschke, S., Nauber, G. and Welker, K.

WELKER, K., see Matschke, S. and Welker, K.

WERNER, H., Die Anwendung von Bildtransformationsverfahren auf die Auswertung von Pulver-
aufnahmen (The use of image transformation methods in the evaluation of powder photographs),
Wiss Z Humboldt-Univ Berlin, p. 610, 1962. *21, 55*

WHITE, T., see Vancouleurs, de, G.

WIEMER, A,. see Lehmann, R. and Wiemer, A.

WULFF, W., see Seidel, W. and Wulff, W.

YALOUSSIS, E., see Holfelder, H., Bornhauser, O. and Yaloussis, E.

YOTSUMOTO, H. and Ito, K., Colour photographs by electron microscopy, *Bull Microsc appl*,
6, 145, (1950). *34*

YVON, see Jobin, M. M. and Yvon.

ZAPF, K., see Rakow, A. and Zapf, K.

ZORLL, U., Die Genauigkeitsgrenze der Dickenmessung von dünnen Schichten usw. (The limit of
accuracy in measurements of the thickness of thin layers, etc.), *Optik*, 9, 449, (1952). *9, 12*

X. INDEX

(The abbreviation equ. stands for equidensities)

135